Josep Lluís

Joan

Sert

Miró

Josep Lluís Sert

Joan Miró

HDi

HARPER
DESIGN
international

An Imprint of HarperCollins*Publishers*

Publisher **Paco Asensio**

Editorial Coordination and texts: **Llorenç Bonet**

Translation: **William Bain**

Art Director: **Mireia Casanovas Soley**

Graphic Design & Layout: **Emma Termes Parera**

Miró's Works: © **Successió Miró, 2003**

Photographs of Sert: © **Marc Mormeneo: 16-17**
 © **Pere Planells: 19, 20, 21, 32-35, 41, 45, 47, 50, 57, 60, 61, 69, 71, 73**
 © **Michael Hamilton: 26-31, 36-39, 48, 59**
 © **Jordi Miralles: 15, 40, 52, 61, 66, 67**
 © **Roger Casas: 22, 23, 24, 65**
 © **Joan Ramon Bonet and Dieter Bork: 19, 21, 63**

We would like to show sincere gratefulness to the Fundació Miró de Barcelona, specially to Ingrid Fontanet and Teresa Montaner; and also to the Successió Miró and Manuel Barbié.

First published in 2003 by:
Harper Design International,
an imprint of HarperCollins*Publishers*
10 East 53rd Street
New York, NY 10022

Distributed throughout the world by:
HarperCollins International
10 East 53rd Street
New York, NY 10022
Tel: (212) 207-7000
Fax: (212) 207-7654

HarperCollins books may be purchased for educational, business, or sales promotional use. For information, please write:
Special Markets Department HarperCollins Publishers Inc. 10 East 53rd Street New York, NY 10022

Library of Congress Control Number: 2003109564

ISBN: 0-06-056421-0
DL: B-52.648-03

Editorial project

LOFT Publications
Via Laietana, 32 4º Of. 92
08003 Barcelona. España
Tel.: +34 932 688 088
Fax: +34 932 687 073
e-mail: loft@loftpublications.com
www.loftpublications.com

Printed by:
Anman Gràfiques del Vallès, Spain

January 2004

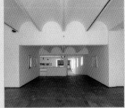

Contents

Joan Miró and Josep Lluís Sert: the myth of the Mediterranean

The large economic and cultural powers in Europe at the beginning of the twentieth century were principally England, France, and Germany. The countries of the Mediterranean basin were considered exotic places where one might go to visit the ruins of the past but were not considered capable of progress and modernity. In the 1920s Sert and Miró were beginning their careers and, in the process, cast their lots with the south. They dispelled this notion of a backwards Mediterranean, working as much from the deep roots of their native Catalonia as from the cultured environment of the Barcelona of the new century. In this way they launched their modernism. Both artists, in spite of forming a part of active European vanguardist movements, always maintained their own unique and personal characteristics. And they were always closely tied to what they learned in the Iberian Levant: Miró's very strong attachment to the Camp de Tarragona region where, by his own account, the seed of his work resided; and Sert's fascination with the typical buildings of the Balearic Islands and the Catalan coast and his intelligent solutions, such as the central patio and the Catalan arch.

This close bond with their country, far from closing them into localism, served to create a world from which the particular would prove able to take in the human. Both men always took an interest in apperceptive forms: what their own lands taught them would serve their understanding of humanity, enabling their work to speak to any human being, regardless of their origin.

Sert and Miró were close friends. They shared the same interests and concerns, not only because they were from the same generation and had grown up in the same city, but also because of similar life experiences. Their focus was simplicity and getting at the essence of things. The attraction toward the human is basic in both artists. Moreover, in spite of the formal differences in their artistic achievements (given the profession of each), the connection between their work is also evident. their similarities are perhaps most apparent in the painter's studio in Palma, Majorca, and in the Miró Foundation in Barcelona where the two men worked together. In these spaces one perceives the ease with which the works of Miró live in the buildings designed by Sert.

The elements of balance, space, light, color, and the popular arts are those through which we may approach the shared world of these two artists. We do so always through a fundamental common link: the Mediterranean. Contained in this are simplicity, the love of a country, surprise in the face of daily reality, and a love of refining nature.

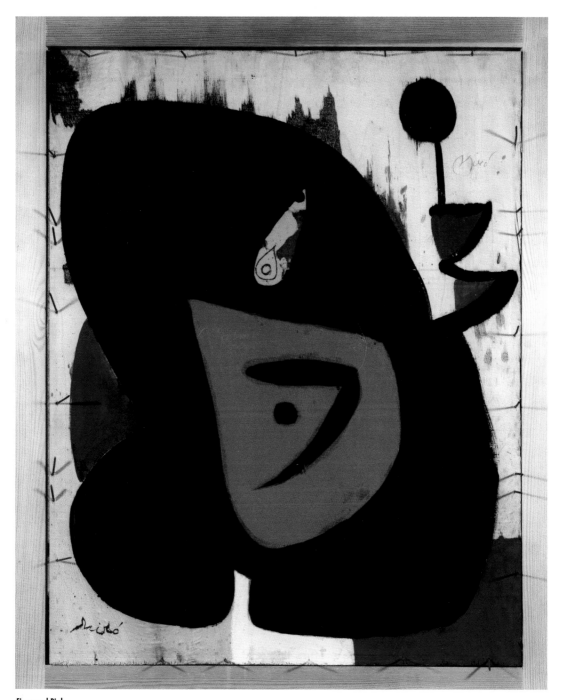

Figure and Bird
1977. Oil on wood (29^9/$_{10}$ x 23^1/$_5$ inches)

JOSEP LLUÍS SERT 1902-1983

Josep Lluís Sert was born in Barcelona in 1902 to a well-off family with noble ancestry (the Counts of Sert) and was educated in cultured surroundings. After completion of his basic studies, he registered at the Higher School of Architecture (Escuela Superior de Arquitectura), where he studied from 1921 to 1928. Here, Sert developed contrary views to the teachings of the "accademicista" style and joined with like-minded students to organize exhibitions in the Dalmau Gallery, one of Barcelona's leading galleries at the time. This particular group was much influenced by the ideas of Le Corbusier, whose books Sert had bought on a trip to Paris. The admiration went far enough for the group to invite the Swiss architect to two conferences in Barcelona. This was the first face-to-face contact between Sert and Le Corbusier, and, in 1927, the young Catalan worked in Le Corbusier's studio in Paris. The two men kept up a steady correspondence in later years.

In 1929, the GATCPAC (Grup d'Arquitectes i Tècnics Catalans per al Progrés de l'Architecture) was founded by Catalan architects, along with a similar group of like-minded Spanish architects (GATEPAC or Grupo de Arquitectos y Técnicos Españoles por el Progreso). Their shared headquarters was inaugurated in Barcelona two years later, with exhibitions, a café, conference cycles, and other activities, including the journal A.C., short for Documents d'Activitat Contemporània. All of this activity, which included contact with the European countries to the north (the group would become part of CIAM—the International Congress of Modern Architecture) came to fruition in 1931, at the time the Second Spanish Republic was proclaimed. The Catalan government, the Generalitat, began a program of schools, hospitals, and services on which the Barcelona group focused. In Europe, as one may judge from the correspondence between Le Corbusier and Sert, Spain and Catalonia were looked on as an architectural backwater, even as the tenets of modern architecture merged with those of southern climes. But the coup attempt of 1936, with the collaboration of the governments of Mussolini and of Hitler, and the subsequent Spanish Civil War (1936-1939) destroyed all hopes of the modernization which shortly came to pass in the rest of Europe.

In spite of the scarcely five years of life of the Republic, Sert, along with Josep Torres Clavé (1906-1938) and Joan-Baptista Subirana, erected the Casa Bloc (1936), the anti-tuberculosis hospital in Barcelona (1935) and, with Luis Lacasa, the famous Spanish Pavilion at the 1937 World's Fair in Paris.

The Franco takeover in Spain in 1939 caused GATCPAC to disband: Subirana, expelled from the College of Architects, remained in Barcelona but did no more building; Torres Clavé died at the front; and Sert went into exile, going first to Paris and then, in the face of the Nazi occupation, and with only scant means, to New York.

After becoming a United States citizen, he began a new phase in his career: in 1943 he published a collection of CIAM design documents, Can Our Cities Survive?, which became the basic text

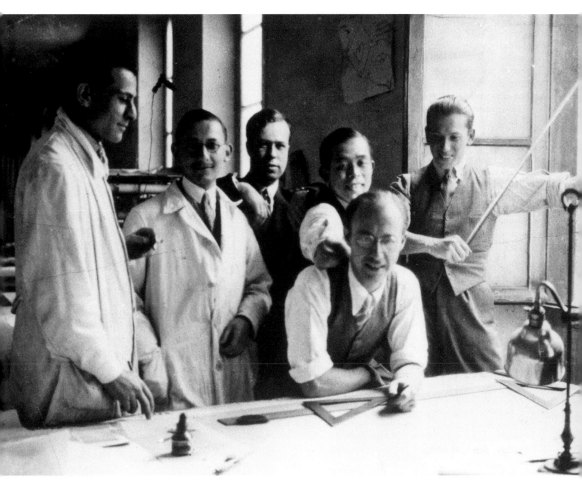

Sert—third from left—in the office of Town Planning Associates

in university architecture programs throughout the United States. Simultaneously, Sert began to give conferences, at the invitation of other European exiles like Richard Neutra (1892-1970), Marcel Breuer (1902-1981), and Ludwig Mies van Der Rohe (1886-1969). Towards the end of the 1940s, the ideas of the Modernist movement appeared to fit well with an administration concerned with social issues, but the McCarthyism of the time and the fear of any ideas with a socialist bent—the ideas shared by the majority of these architects—broke up any possibility of developing a modern program.

In 1945, Sert became associated with Paul Lester Wiener (1895-1967) and Paul Schulz. Together, these men created Town Planning Associates, a firm that focused on planning and developing new cities and restructuring major metropolises, primarily in Latin America.

The political changes of the 1950s once again modified the world architectural scene and thus Sert's profession. The struggle between United States interventionism and the Communist revolutionary movements put an end to the possibility of building in Latin America, now a cold war battlefield.

In 1953, Sert was appointed dean of Harvard University's Graduate School of Design, succeeding Walter Gropius (1883-1969). He approached Urban Design (urbanism) as an idea of small interventions in the fabric of the city, interventions that were well researched and concrete. On a professional level, this meant opening the offices of Sert, Jackson and Associates, abandoning town planning and centering his work on the same ideas he was teaching in the university.

Sert presided over two congresses of CIAM (1949 and 1956), the latter of which resulted in the dissolution of the organization, which affected Sert personally. Even so, he maintained, both in his classes and as a professional architect, his interest in creating a balanced habitat where people are always in contact with their environment.

In 1969, he retired as dean and professor at Harvard. Contact with his native Catalonia had increased as the grip of the dictatorship of General Franco began to loosen and the Fascist ideological hold was abandoned or replaced by a strange hybrid of capitalism and caciquism. Sert's open return to Barcelona in 1975, and the construction of the Miró Foundation, were landmark events for the city.

Sert, who died in Barcelona in 1983, is one of the key figures of twentieth-century architecture. His important work at Harvard places him as one of the first advocates of the modern architectural movement in the United States.

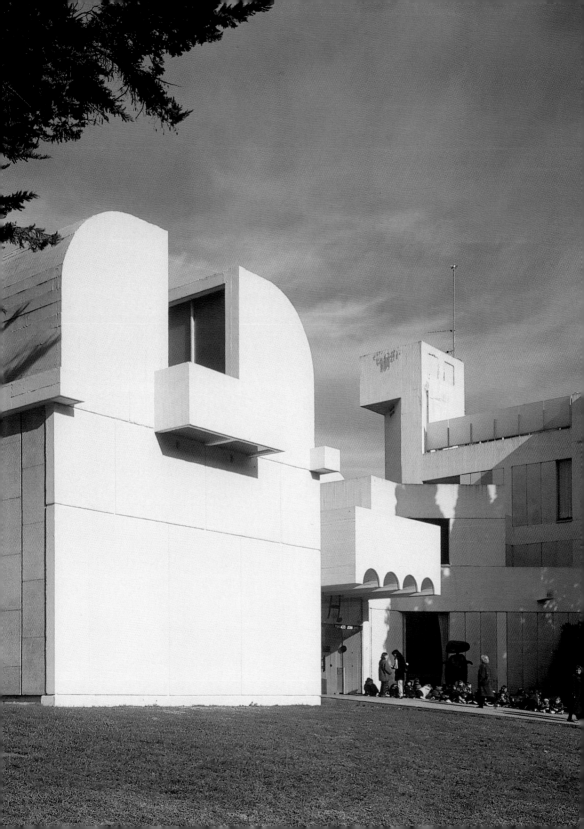

Spanish Pavilion

1937

Jorge Manrique 9, Barcelona, Spain

In 1937, amid the full rage of civil war, the Spanish Republic's government participated in the Paris World's Fair, where a presentation of artworks included important pieces such as Alexander Calder's *Mercury Fountain*, Julio Gozález's *Montserrat*, Pablo Picasso's *Guernica*, and Joan Miró's *The Reaper*. The pavilion was commissioned to Sert and to Luis Lacasa, who worked under deadline to get the project ready.

Sert, who had designed an art exhibit room that could be dismantled for use in itinerant exhibitions for GATCPAC, already had some idea of what the pavilion should be. The decision was made that, apart from showing the works of people of renown, there should be a staging of popular work and a set of informative panels on the situation in Spain before and after the Republic and on the state of the country in the midst of war. The solution for Sert and Lacasa was to erect a three-story building that opened onto a canvas-roofed patio which functioned as an auditorium. The first floor was accessed by a staircase, the second floor by a ramp, and a vertical entrance was also inside the structure. The interior space itself was designed as an exhibition room with panels establishing a set path, easily changeable according to the needs of the moment.

The pavilion was destroyed at the end of the fair, an unfortunate moment when the Miró piece, *The Reaper*, was also lost. In 1992, the pavilion was reconstructed in Barcelona, where it currently houses a library on the Spanish Civil War.

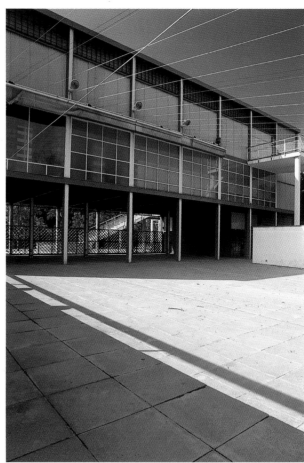

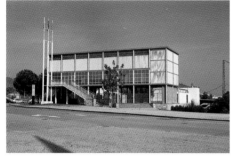

14

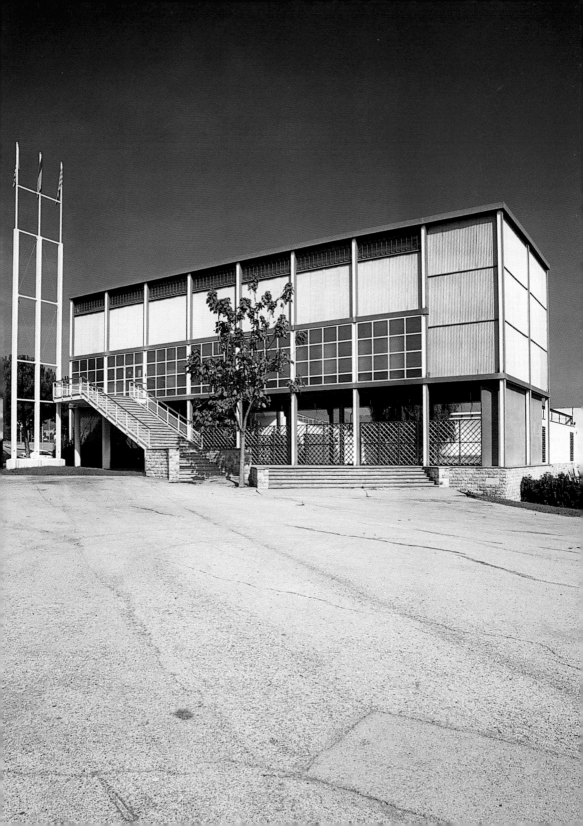

STUDIO OF JOAN MIRÓ

1955

Joan de Saridakis 29, Palma de Mallorca, Spain

Joan Miró had always wanted to have a spacious workshop where he could work on large canvases and sculptures. In the 1950s, the means to actually achieve this were at his disposal, and he contacted his friend Josep Lluís Sert. The latter, while unable to practice professionally in Spain due to the political purges in the wake of the Civil War, took advantage of the permeable borders during Franco's dictatorship of the "interior exiles"—the Balearic and Canary islands—and went ahead with the project.

The studio is a freestanding building beside the house Joan Miró and his wife had outside Palma, a *masía* (farmhouse) surrounded by almond trees and carob trees on the slope of a hill. The shop adapts itself to the change in grade, marked by two separate plots with three different access paths: one along each plot and a third from the flat roof. The most direct entry is from the house, which is on the same level.

One typical element in all of Sert's architecture which debuted here is the arched window permitting altered overhead lighting that softens the strong Mediterranean natural light. With this solution, Sert adapted the modern concept of good lighting to the southern climes, where the northern European requirements of large apertures are obviated and the use of shade against the strong light is lessened.

Miró liked the studio so much that he took not only his large-format works but his entire production there. When he wanted to see how work was progressing, he liked to sit down on a swing in front of the piece in question to study the way the light, during the course of the afternoon, illuminated the colors he had painted on the canvas. The control of light in an interior space that was comfortable and agreeable to the painter and that respected the exterior environment was Sert's great challenge and triumph.

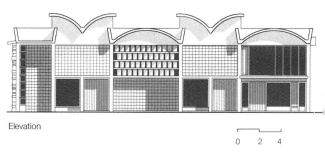

Elevation

0 2 4

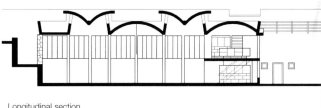

Longitudinal section

0 2 4

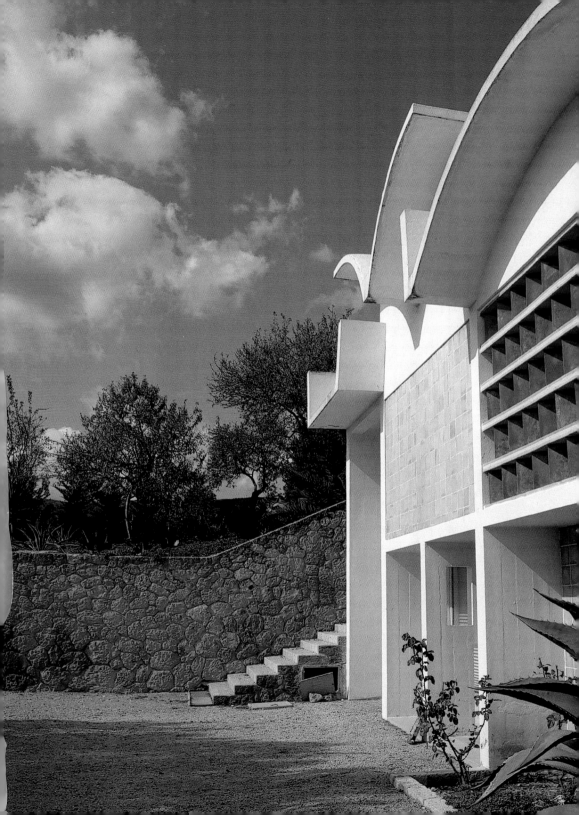

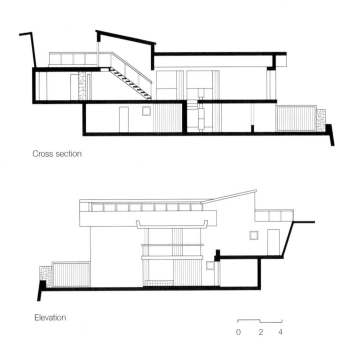

Cross section

Elevation

0 2 4

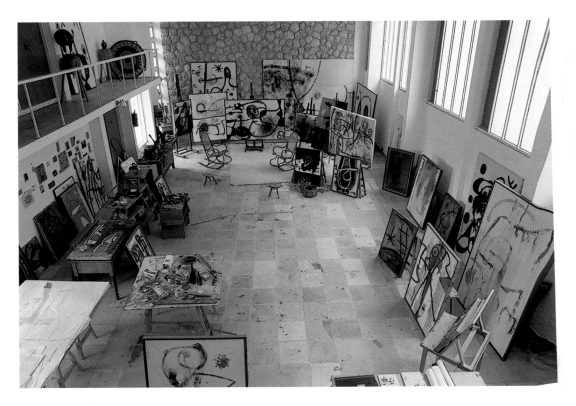

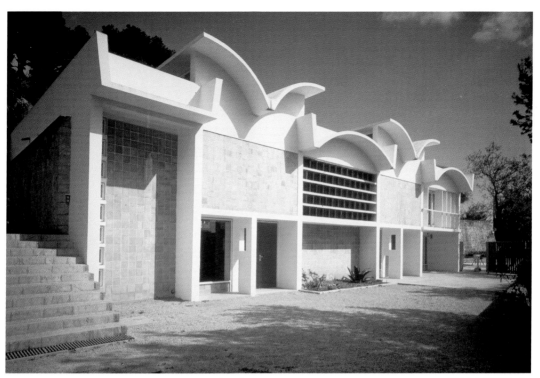

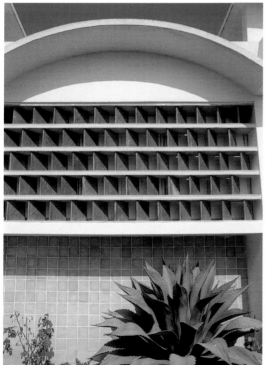

MAEGHT FOUNDATION

1959- 1964

Chemin de Gardette, Saint-Paul-de-Vence, France

Miró's agent in Paris, Aimé Maeght, had wanted to create a museum for his private collection for some years but had no concrete plan in mind. On a visit to Miró in Palma, he was impressed by the painter's studio, and made contact with its creator, Josep Lluís Sert. The Catalan architect seemed to Maeght the ideal person to do his museum: Sert had not only known many of the artists whose work made up the Maeght collection, he also had innovative ideas and was capable of listening to and working in collaboration with the collector. Thus was the project for the Maeght Foundation born—a building that was created expressly for the specific works to be displayed on its walls and that allowed for the necessary possibility of extending the space in successive stages. The initial project housed the artwork around a central patio with four exhibition rooms providing the viewer access to the permanent collection. Each room was dedicated to a different artist: Joan Miró, George Braque (1882-1963), Marc Chagall (1887-1985), and Wassily Kandinsky (1886-1944). An additional space was inserted into the original set to show the work of younger artists. Somewhat apart from this main nucleus was the house of the director of the foundation and, at the back, the guard's house.

Not unlike Joan Miró's studio, the Maeght Foundation features specially shaped arched skylights which create a homogenous light in all of the rooms. The walls are reserved for supporting the frame and/or hanging the works, with the apertures used only to interface with the gardened exterior spaces.

With 1973 expansion, the whole structure further reaffirmed its "small-town" feel. More than a building, the Maeght Foundation is a linked series of edifices which integrate interior patios with exterior vegetation, and the whole site with the landscape, including fantastic views of the Alps to the north and the Mediterranean Sea to the south.

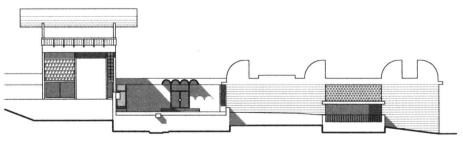

Longitudinal section

0 2 4

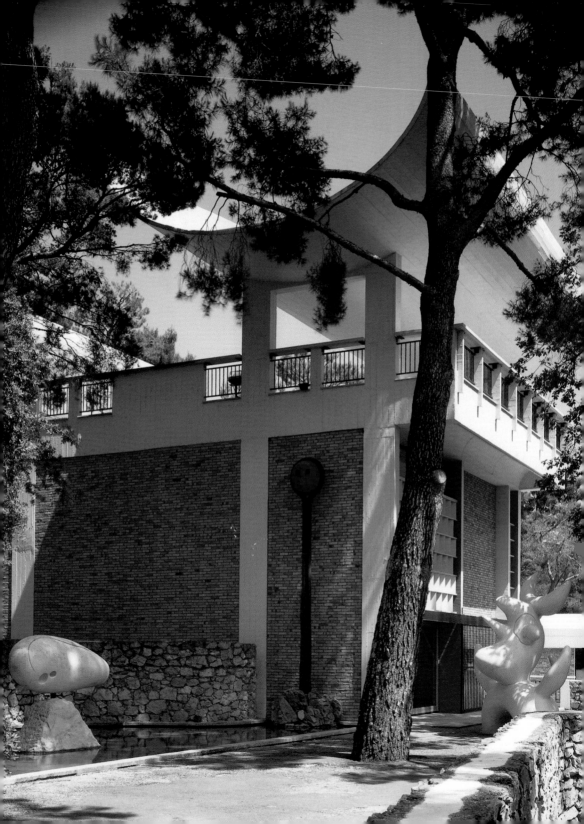

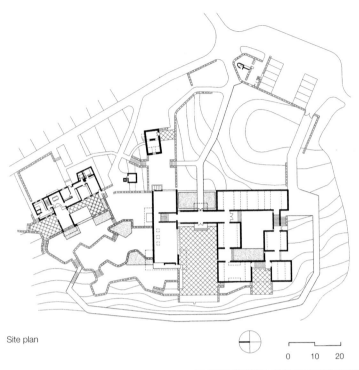

Site plan

0 10 20

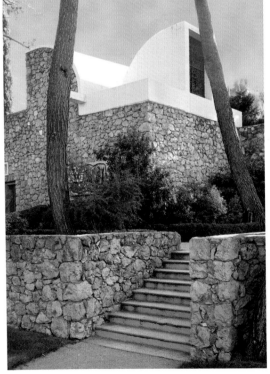

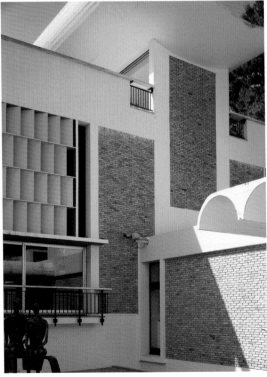

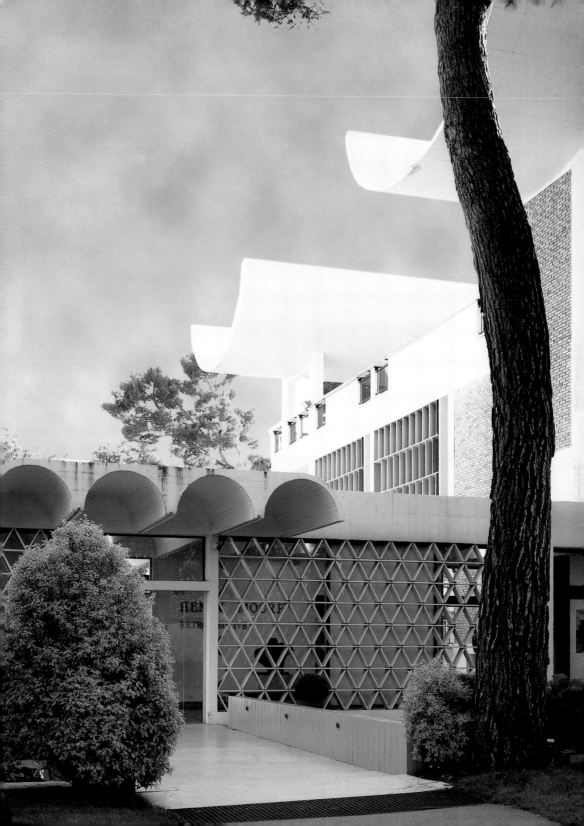

PEABODY TERRACE

1962-1964

By the 1960s, owing to the international political climate, Sert's professional focus shifted from Town Planning Associates' master plans and urban analysis in Latin America to architectural projects with specific roles in their individual urban landscapes. These projects reflected his teachings on urbanism, and he continued to research the relationships between architecture and society.

The residence hall for married students at Harvard University stemmed from part of an overall plan for the institution that developed in stages. Sert's idea was to delineate the campus in its own zone, since the growth of the university had begun to invade and verged on absorbing the city of Cambridge. Peabody Terrace is a cluster of buildings that mark the transition between town and campus. It has a high density of living spaces (90 per acre), and this generated the need to build upward. The three 22-story towers distinguish the edge of the campus from the city, although three-story buildings dominate (as they do in the surrounding neighborhood).

There are three types of standard apartments, the one-, two-, and three-room dwelling, according to family needs. Most of the services are communal, and there are many shared terraces, which include small gardens, based on the idea of generating dialogue and social interaction in university life.

Sert had earlier developed the idea of a residence hall with communal spaces in the Bloc House in Barcelona in 1936. This house was influenced by the concept of workers' residences that came out of the Modernist movement, and Sert later returned to this concept with in the Roosevelt Island project in New York in 1974.

Memorial Drive, Cambridge, Massachusetts, USA

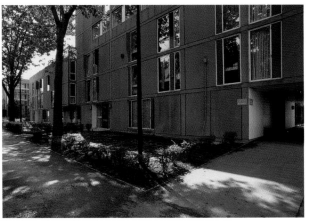

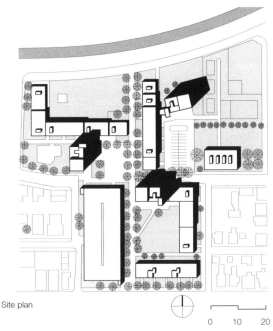

Site plan

0 10 20

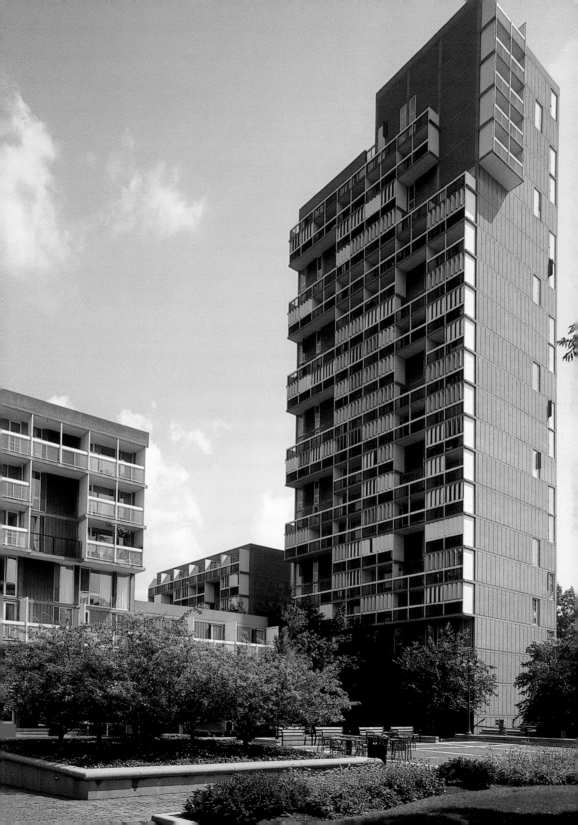

BOSTON UNIVERSITY

1963-1966

765-775 Commonwealth Ave., Boston, Massachusetts, USA

At the beginning of the 1960s, based on a similar model to the one developed at Harvard and other universities in the United States, Boston University sought to rationalize its space. In this case, the plan was to centralize all of the departments spread throughout the city and transfer them to lots on the Charles River.

The project, as Sert outlined it, consisted of creating three new buildings—the George Sherman Union, the School of Law, and the Mugar Memorial Library—and slotting them into the area of preexisting buildings with the full intention of reordering the territory. The most visible change in this whole operation, closely following the proposals of teachers of urbanism, was to turn the buildings to face the river and to include multiple green areas. The complex has its back turned to Commonwealth Avenue, which in this section is a highway. The improved integration of the site is unquestionable.

Implementing the proposed changes on the existing site meant densely setting the new buildings. Thus, the School of Law took on some height, including a tower of nearly twenty floors. The most highly trafficked zones, however, are on a grade, i.e., the auditorium and the Law Library, a two-story annex to the large tower, with accessways from the tower as well as from the exterior.

Mugar Memorial Library, set perpendicular to the Charles River and to Commonwealth Avenue, acts as a visual reference point simply because of its peculiar form, with three large stepped terraces. With a capacity of a million and a half books and 2,300 readers, the library is a key piece in the complex, not only because of this high number of daily visitors but because of its central location and the flow of pedestrian traffic which is organized around it.

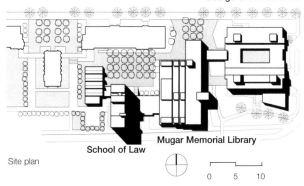

George Sherman Union

Mugar Memorial Library

School of Law

Site plan

0 5 10

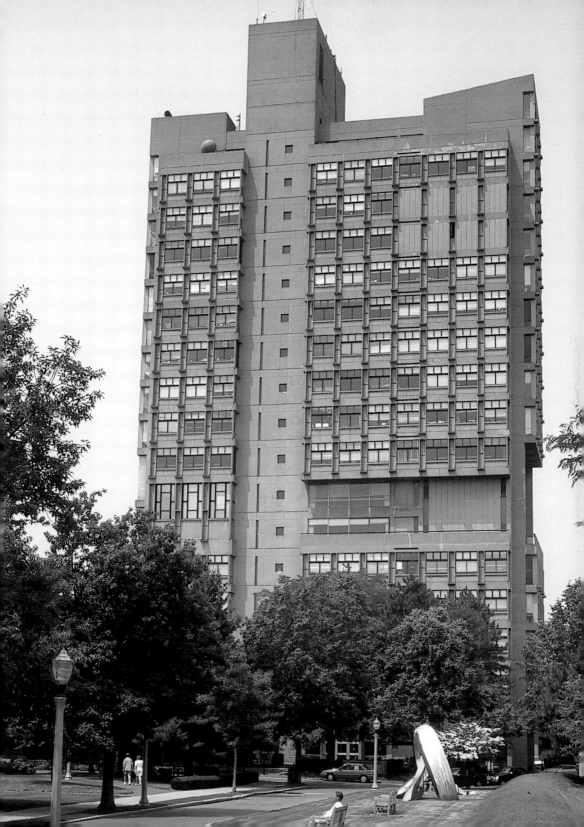

Mugar Memorial Library

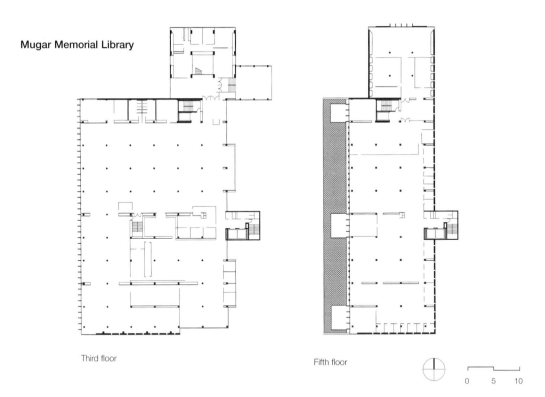

Third floor

Fifth floor

0 5 10

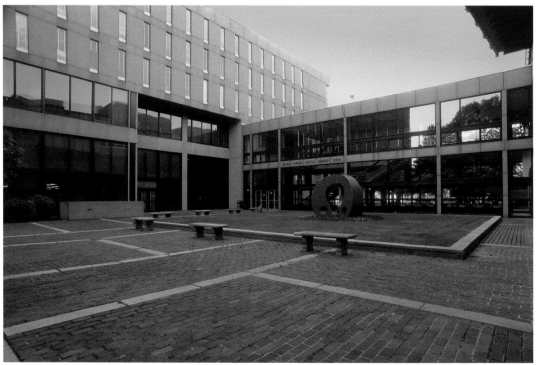

George Sherman Union

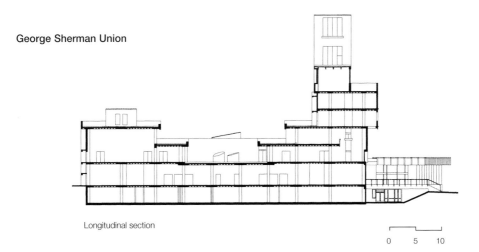

Longitudinal section

0 5 10

HOUSES IN PUNTA MARTINET 1966-1971

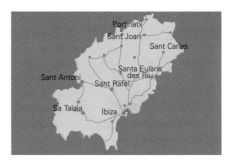

Ibiza, Spain

In Punta Martinet, the cape that closes the bay of the city of Ibiza, Sert constructed a small cluster of summer houses, a total of nine in all. One of these was for his own use, and the others were for friends and acquaintances. Harmonizing the structures with the given environment was one of the architect's concerns. This led him to respect the already existing plots of land which organize the configuration of the terrain and also to respect local building forms and materials, conflating them with Le Corbusier's proportion-based Modular system. On the facades of these houses, pure whitewash was alternated with pigmented whitewash (in ochre or other earth tones).

The absence of walls to separate the dwellings and the arrangement of the plots give the houses the appearance of being more like a traditional Ibizan town than a modern city. The respect shown the existing landscape is evidenced by a detail: Sert slotted in a single swimming pool, serving his own house, by taking advantage of a small watering tank that was already there and that required practically no adaptation.

As the Balearic Islands had, since the 1950s, been considered by the Francoist dictatorship an area of punishment—exiled from the interior—the climate had become increasingly progressive, closely linked to Barcelona and to Europe. Because of this context of openness, Sert decided to move to Ibiza when he retired from his position as Dean of Harvard in 1969.

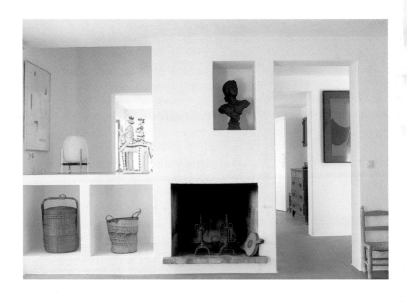

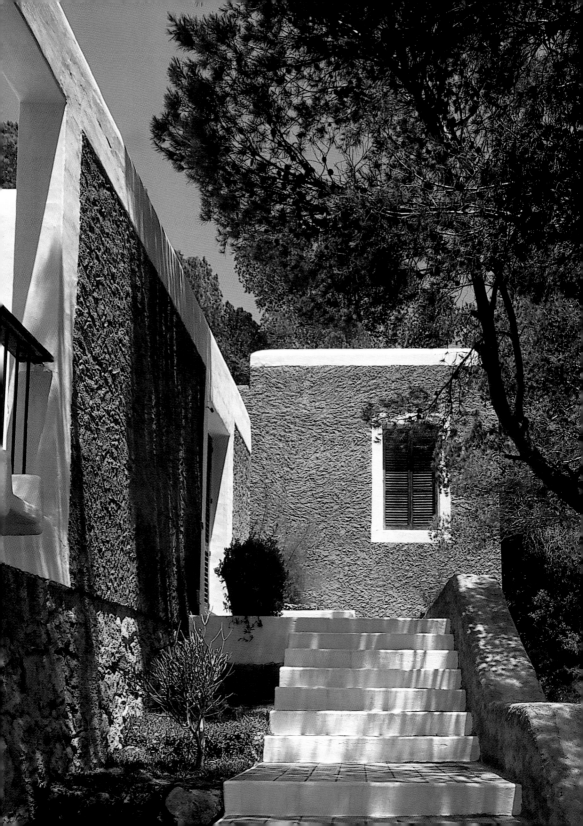

Francesc Sert House

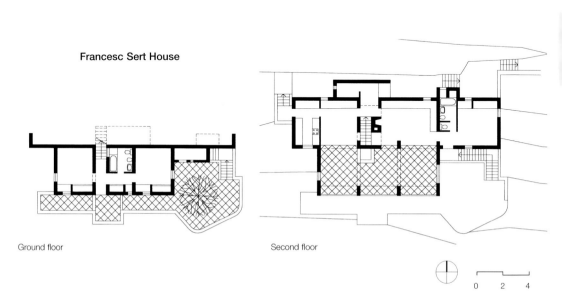

Ground floor

Second floor

0 2 4

Valls House

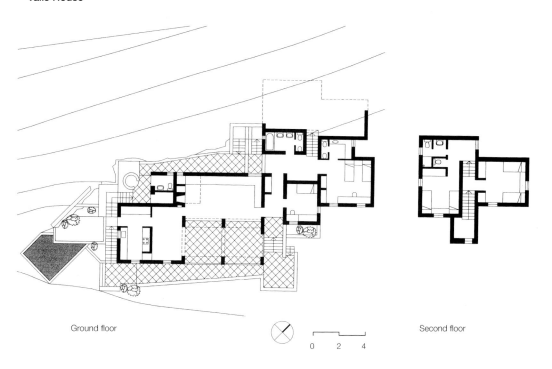

Ground floor 0 2 4 Second floor

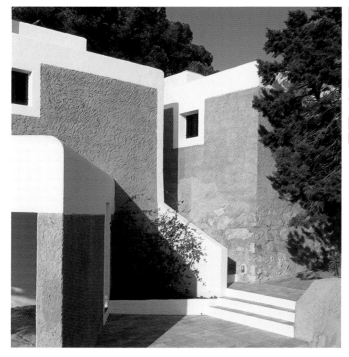

SCIENCE CENTER

1973

Oxford Street, Cambridge, Massachusetts, USA

This is the last building that Sert designed for Harvard University, and was completed after sixteen years of projects studying ordering and growth that Sert had commenced in 1957. The Science Center connects the north campus to the south via an interior passageway running in a straight line through the whole building. This hallway also diffuses crowds in the building's most heavily trafficked sectors: the cafeteria, the auditoriums, the book store, and other service areas.

Parallel to the corridor, which is a glassed-in gallery, a block of laboratories rises up gradually, with a maximum height of six stories. The center of the building juts out in a T-shape and houses the science departments, including the classrooms and study rooms. The science departments are laid out like stair steps allowing for large patios on each floor. On both sides of this section, other units rise up, no taller than two stories: on the Oxford Street side is the library and the cafeteria, with a patio between them; on the other side are four lecture halls with distinguishable exteriors.

Like all of Harvard's buildings, given the university's policy of economic and territorial containment, the construction of these structures had to be done rapidly and in a limited space. Hence, pre-fabricated units were used, and the maximum height was limited to nine floors, although this height was only reached by the Astronomy department in one wing, occupying a confined space.

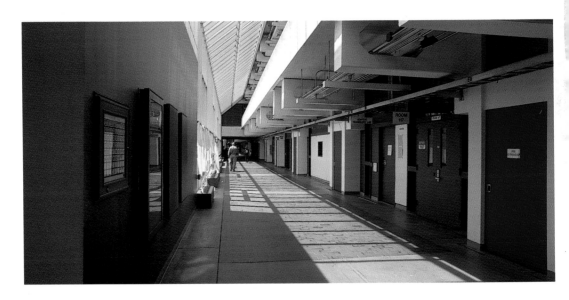

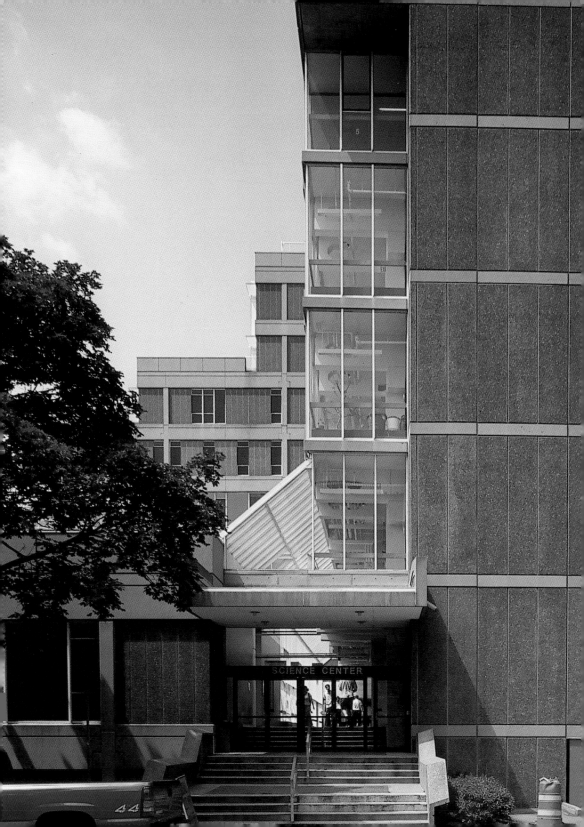

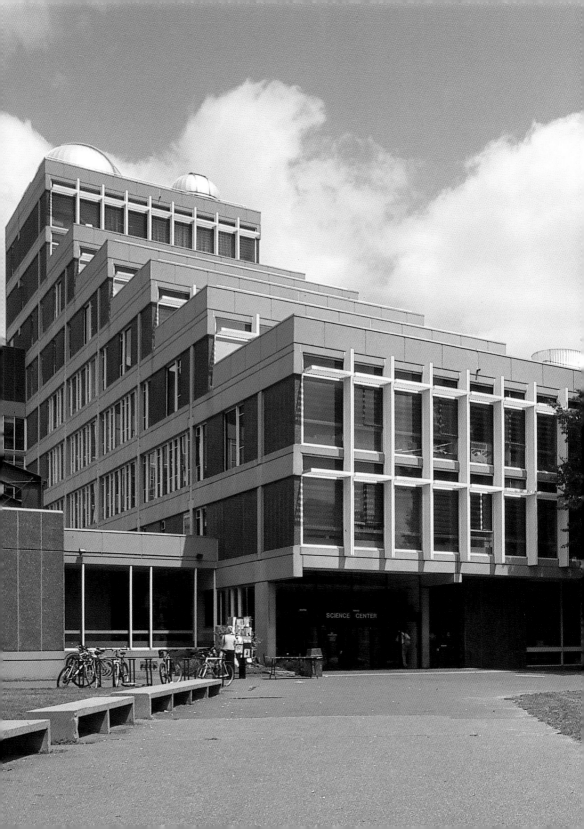

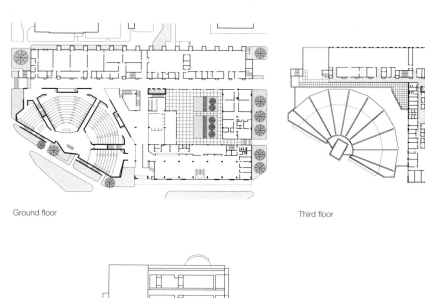

Ground floor

Third floor

0 5 10

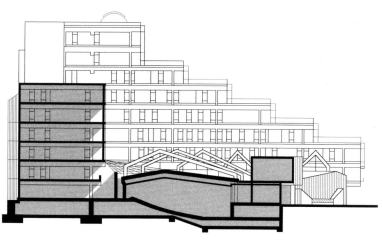

Cross section

0 5 10

Joan Miró Foundation 1975

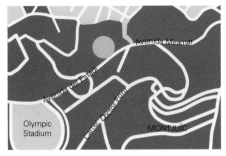

Avenida del Estadi, Barcelona, Spain

An important event for Barcelona, The Joan Miró Foundation for the Study of Contemporary Art was inaugurated in 1975. The city had, at the time, been able to lay claim to only a very limited cultural infrastructure in spite of its international fame. The foundation was born with a dual purpose: to house the legacy of artwork which Miró had bequeathed to Barcelona and to serve as a cultural engine for the city, dedicated to contemporary art in all of its facets. The building itself was designed with two types of structures with two intended purposes: an exhibition space, with a hall and passage through the rooms that even today is the envy of any museum, and a study center, with an auditorium, a library, and an archive. This set-up allows for the possibility of future expansion in line with the institution's needs. One such addition was designed years later by Jaume Freixa, the closest of Sert's collaborators in Catalonia.

The building designed by Sert is a mature work that perfectly mixes the proportions based on the Modular system with the language of traditional Mediterranean architecture. Importantly, it also looks out onto the city from Monjuïc Hill.

While the exhibit half of the plan emphasizes the journey through and continuity of the space—not only among rooms, but among exteriors such as patios, gardens, and sculpture terraces—the cultural center is grouped around a single octagonal structure.

In 1975, Sert was readmitted to the College of Architects of Catalonia and the Balearics in a ceremony held in Madrid. This represented his professional reunion with his native city after 35 years spent in exile.

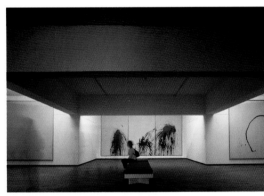

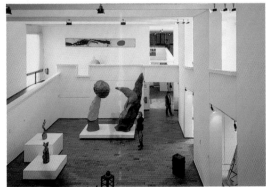

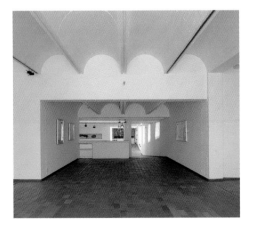

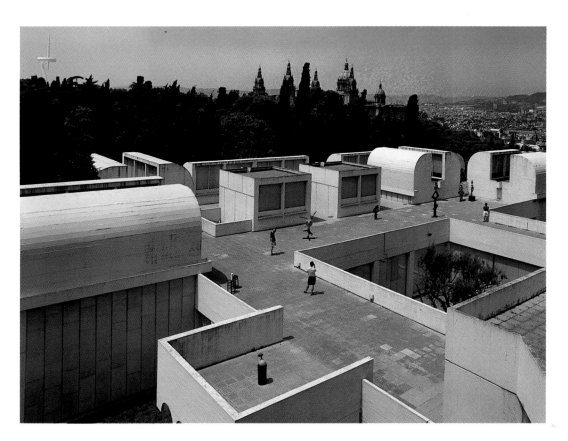

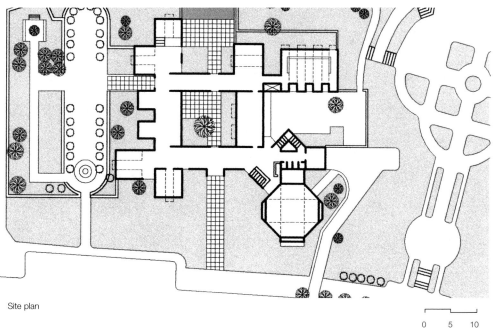

Site plan

0 5 10

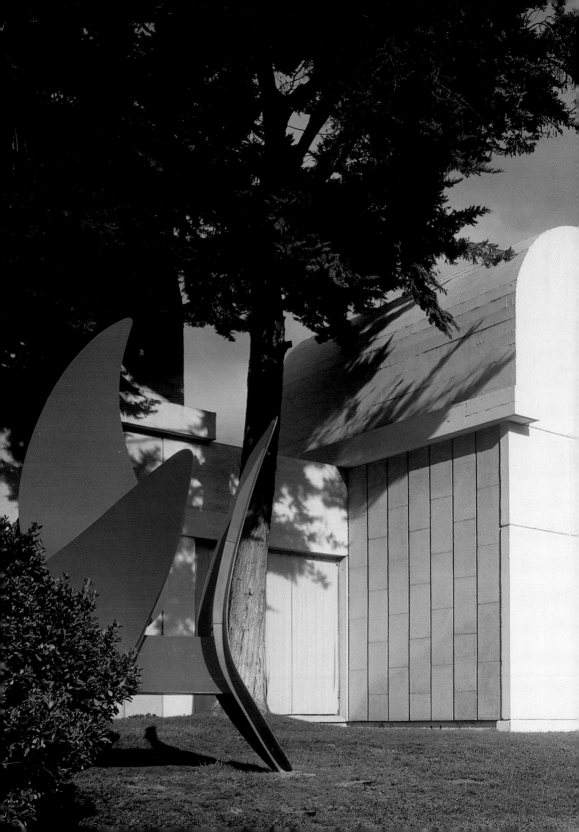

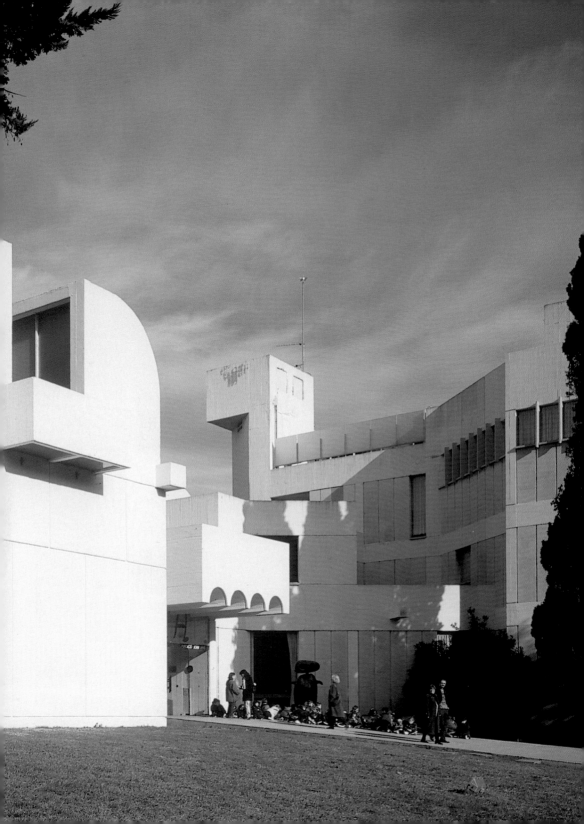

JOSEP LLUÍS SERT-JOAN MIRÓ

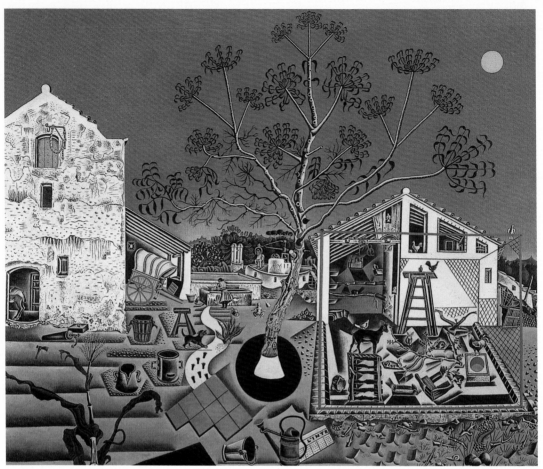

The Farm
1921-1922. Oil on canvas (52 x 57⁷/₈ inches)

A COHERENT WORLD

Balance in architecture, painting, and the environment

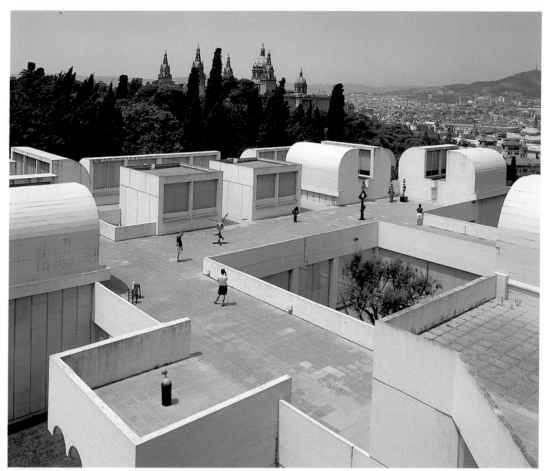

Joan Miró Foundation

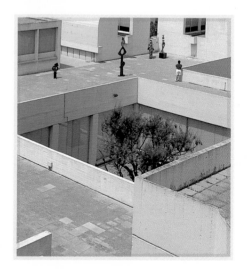

The relationship of balance between a farm worker and his land fascinated Miró, and in the surrealist circle they said that his need to return to Montroig was due to the relationship he himself had with the land, the same as that of the farm workers. Sert, in his urban planning, tried to create a coherence among all the elements involved: houses, traffic, nature, and people—all in equilibrium.

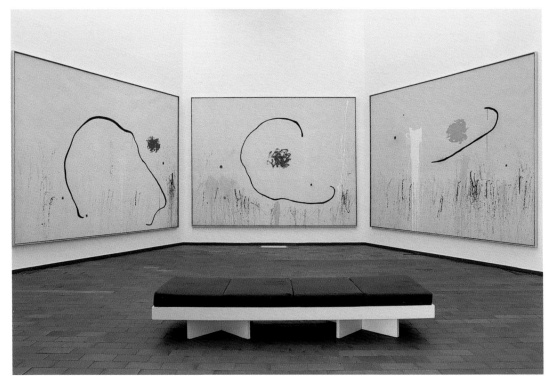

**The Hope of the Man Condemned
to Death I, II, III**
1974. Acrylic on canvas
(105¹/₄ x 138¹/₅ inches,
105¹/₄ x 138¹/₅ inches,
105¹/₄ x 138 inches)

Modest Urgell (1845-1919) was Miró's respected teacher at the Llotja (School of Fine Arts) in Barcelona. Urgell is famous for his Romantic landscape compositions, pieces where a light line separates the sky from the earth. These teachings might be far from the avant-garde, but the simple compositional balance of Urgell's paintings always had Miró's admiration, from his student years on.

In all of Miró's canvases, the idea of balance is perceivable in one way or another. Hence, in *The Farm*, one of the things we see is a world in which the human is in harmony. When faced with Miró's later works, no small number of critics have found that the feeling transmitted is one where nothing is missing and nothing is in excess. They are works with minimal elements where the compositional aspect is in perfect balance. This state of equilibrium is the result of a highly detailed com-

positional technique. Everything is planned out beforehand in the different still lifes and studies, with numerous notes and observations.

One lesson imparted by Sert at Harvard, in the Urban Planning Department, was balancing elements—both the new installations and their relationship to the rest of the city. The idea of a carefully planned city was not very common in the United States, a country where the absence of legislation and the scarcity of historical urban centers had made for uncontrolled suburban growth. The new attention given to measured and controlled urban growth was also present in Sert's work in Latin America. In fact, he was one of the first urbanists to consider it absolutely necessary to carry out an extensive study of a city prior to intervening in it, as was done in his pilot plan for Havana, Cuba, 1955-1958.

Two elements as simple as a line and a colored form are enough to create a focus for our attention. The form, or simple blot, carefully realized, and the line, where the painter's vigorous execution is clearly seen, fill the canvas with their otherwise unaided presence. The arrangement of the three paintings correlatively, just as the painter wished, implies a clear spatial relationship by delimiting a space and making (if necessary) the empty space before the painting more evident. However, the concept of this work with space is originally born of the equilibrium between blot and line, which not only fill the canvas with their presence but also project out toward the space.

Up close, the viewer sees how the form, the blot, has been put in with great care and economy—unlike the long black line, which even spatters the lower part of the canvas with paint. This minute care shows that even the line, which seems like something purely gestural, has been drawn on the basis of the strictest theory, following a very clear plan on the part of the painter.

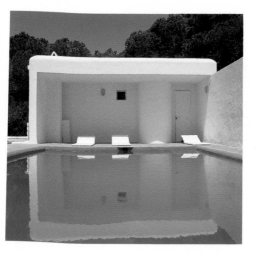

The swimming pool at the Sert house in Punta Martinet carefully mimics the landscape and is open to the other houses in the development, providing the neighboring families with easy access (it is the only pool on the complex premises). For this series of dwellings, Sert took advantage of the walls of the existing terraces, just as he did with the swimming pool, which was formerly an irrigation tank. However, the architect was totally opposed to putting in more pools: in his view, the terrain did not need it, and he wanted to respect its natural landscape.

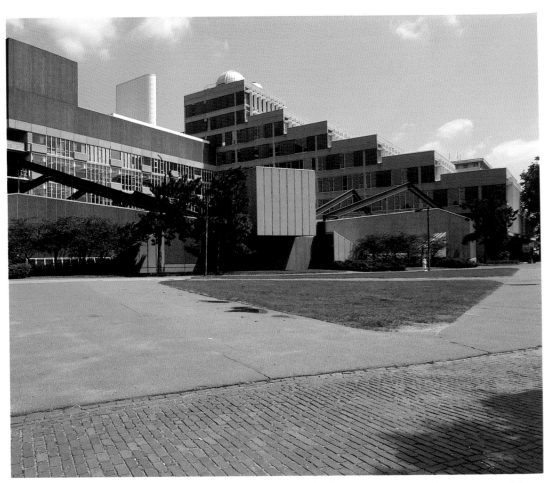

Science Center
1973. Boston

Sert was always concerned with establishing principles of a balanced architecture, one with not only a physical significance to humanity and nature but also a social and cultural relevance. As an architect, he attempted for many years to build a type of housing accessible to manual laborers, such as the Casa Bloc in Barcelona. Sert's attention in his buildings to the environment and to the environment's future inhabitants establish him as one of the first architects to see the city in terms of balance. He explains these ideas in his book *Can Our Cities Survive?*. Today, balance is one of the most widely discussed concepts in long term city planning.

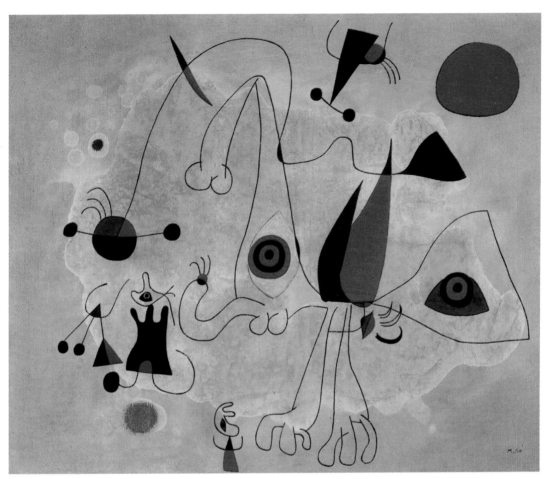

Woman and Birds at Sunrise
1946. Oil on canvas (21¹/₄ x 25¹/₂ inches)

At a time when craftwork was just beginning to be replaced by industrialized products, both Miró—in part because of his family origins—and Sert felt highly attracted to it. In the handmade object, both artists found a balance between people and nature, precisely because these objects are an example of a necessary element for humankind, obtained from materials provided by the Earth itself. They are almost unmanufactured and never superfluous (a quality they both detested).

Interior windows and staircase of one of the Punta Martinet houses

WORKING WITH SPACE

Architectural plan and pictorial space

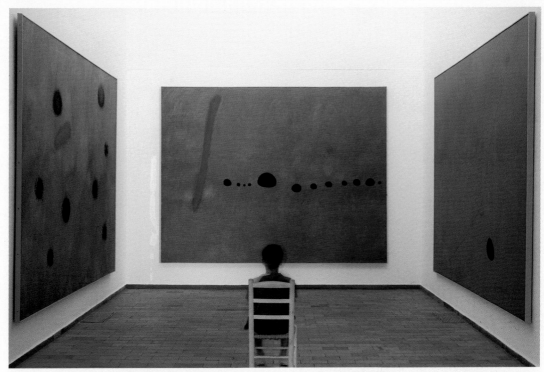

Blue I, II, III
1961. Oil on canvas (106$^1/_3$ x 139$^3/_4$ inches)

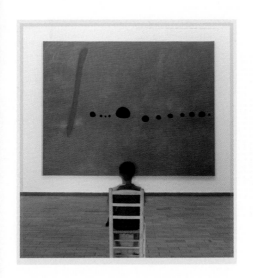

In the Ibiza houses, Sert opted for an individual solution in the staircase: above it, the walls open out into two small windows, as one can see in the photographs on the left. From these windows, it is easy to see who is coming up the stairs and to simultaneously maintain visual contact with two rooms that are not directly linked. This is a very pictorial way of working, with planes and deep perspectives, and it contrasts with Miró's paintings which offer spatial themes—notably, that of the void.

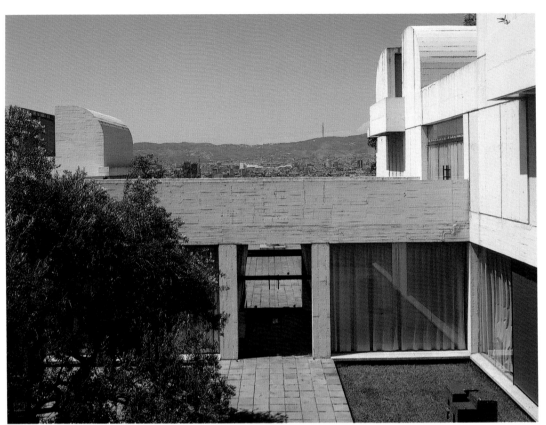

Joan Miró Foundation

The presence of a painting is all that is needed to establish a spatial relationship with the viewer. There is no need to use perspective: the space between the two already delimits an emptiness, a vacuum which the painting can occupy if it is able to go beyond its own limits. In the tryptic series *Blue I, II, III*, Miró investigates this spatial quality of the picture and, while it may seem evident that three planes can define a space, focuses his interest on reaffirming that the void created in front of the painting is emphasized with the three paintings arranged in a U-shape. This way of exhibiting the pictures also establishes a dialogue among them. In it, we submerge ourselves as spectators: a sequential relationship can be established by reading the paintings one after the other, or a relationship of simultaneity, by attempting to perceive them all at once. This will always take place in the vacant space before the painting, so that this place participates in any dialogue that is established between picture and viewer.

In the Punta Martinet development, we find several showers on a round plan on the path from the beach to the houses.

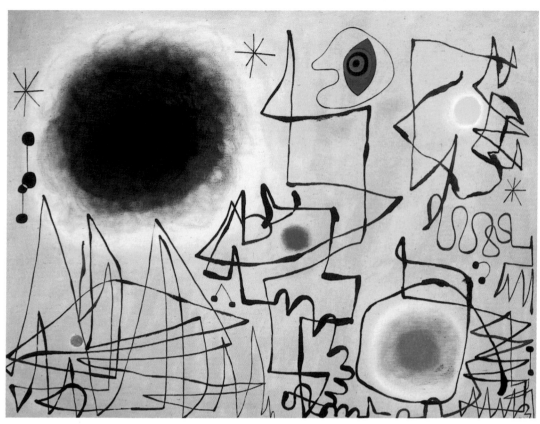

The Diamond Smiles at Twilight
1947. Oil on canvas (38¹/₅ x 51¹/₅ inches)

These are to wash off the saltwater after bathing in the sea before going home. On the wall that closes off the swimming pool of Sert's own house, a small apse protrudes, somewhat like the showers beyond the wall. On the other side of the wall, inside the house, is a shower that projects outward, toward the exterior. The interior is reflected on a plane due to the almost transparent form which indicates, because of the similarity of the other external elements, the location of the bathroom. Sert uses this plane as more than a wall that divides the spaces it contains.

In the Miró Foundation, Sert creates a layout of exhibition panels for the paintings that shape a route that gives preference to the walls more than to any other element: it is an open interior space but one guided by the walls, by the planes that demarcate the journey through the space. What interests the architect here is the exhibitive event, hence he creates perspectives toward a wall because this is where the paintings will be placed. The interior patio around which the edifice unfolds also plays with the superimposition of planes. Here, the walls are large windows and thus nearly transparent, allowing us to see the succession of spaces:

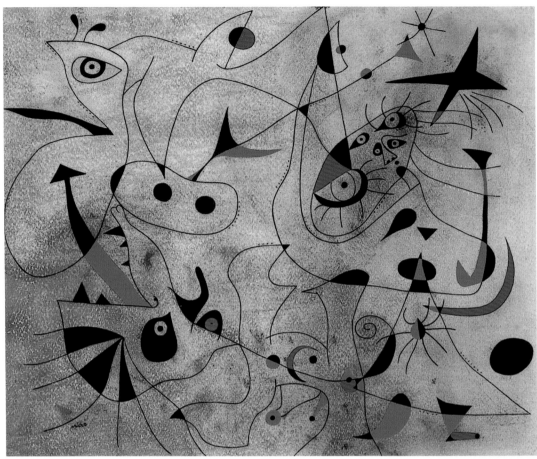

Morning Star
1940. Tempera, egg, oil and pastel
on paper (15 x 18 inches)

first the entrance, then the interior patio, next a passageway, now the outdoor patio exterior, and on until we come to the view of the city of Barcelona, the backdrop that closes the perspective.

The two apparently distant arts of architecture and painting are in fact more related than what might at first meet the eye.

A painter works with spatial elements, and an architect knows how to deal with the language of planes as an element in and of itself. Depending on how we look at it, the roles of the two arts share many features.

Miró's stars are perhaps one of his most well-known signature elements. Since there is no differentiation between background and figure, these elements take on a notable presence: Miró's universe consists of a minimum of symbols and creates an enormously rich language.

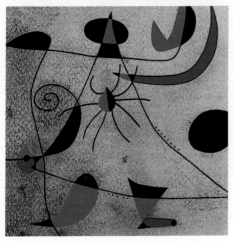

The role of the woman stems from what could be stars linked by a simple line, with the genitalia, in the center, always present and defining the subject. The ensuing dynamic the artist achieves in these compositions is remarkable: the woman is presented as isolated, ecstatic in a smooth frame, like the other elements, yet the relationship is created with lines, with the simple grouping of the protagonists making the entire composition take on a fascinating vitality.

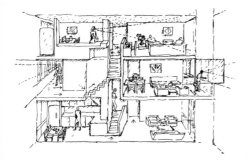

In this sketch by Sert for the Roosevelt Island residences, the architect places much emphasis on the breadth of vision that makes possible the distribution of the spaces: in spite of the reduced dimensions of the apartment, wide visual diagonals are constantly established. Instead of dividing the spaces into closed rooms, the architect establishes a spatial and visual continuity. Hence, the staircase of the duplex opens out to other spaces and doesn't remain closed (as there are no doors or walls on the second floor), thus communicating with the two upper-level bays.

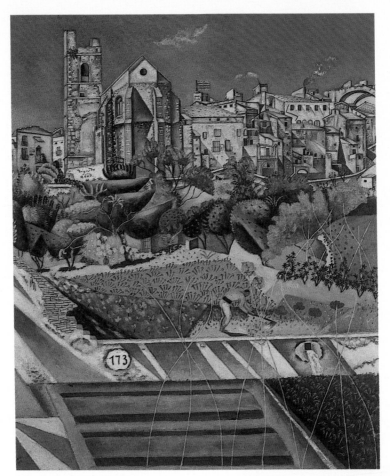

Montroig, the Church and the Village
1919. Oil on canvas (28³/₄ x 24 inches)

SOUTHERN LIGHT

The presence of the sun

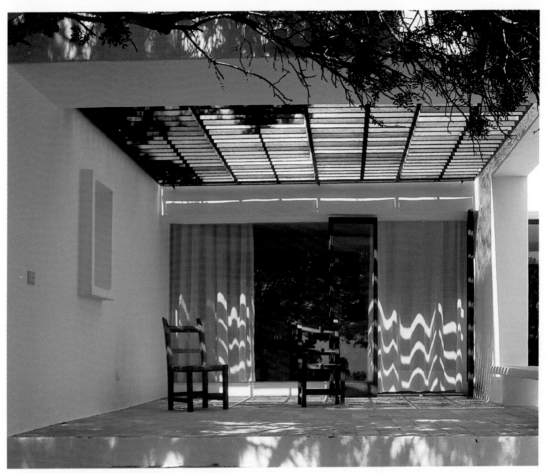

House in Punta Martinet

The brilliant southern light characterizes the landscape of Ibiza, Montroig, and the whole Mediterranean. Both Sert and Miró grew up in this environment: the painter felt the sun's rays on his skin and tried to capture the force of the star; Sert, in turn, was interested in capturing natural light for all of his projects.

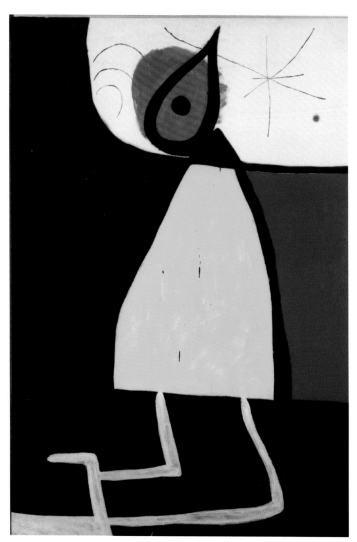

Woman in the Night
1973. Acrylic on canvas
(76¹/₄ x 51¹/₅ inches)

When he encountered the modern movement, Sert realized that the premises for the designs of the architectural vanguard were based on the Central European climate. His generation adapted the modern postulates to different climates and realities: Sert first worked in the Mediterranean, while Alvar Aalto occupied himself with the Nordic regions, and Nyemeyer worked on South America.

One of Le Corbusier's innovations was to create large windows in houses so as to open up the dwelling to the exterior and take maximum advantage of the light. These same windows were a problem when it came to the strong Mediterranean light: too much light and heat came in.

Without wishing to renounce the possibility of creating a greater interaction between the inside and outside of the houses, Sert and the entire GATCPAC group developed different solutions. Many of these were based on traditional Mediterranean architecture. One of the issues of the magazine *AC* was dedicated to the study of traditional Ibizan houses, specifically the materials of the thick walls that so perfectly insulate from the summer heat and the different orientations of the narrow windows, which air the dwelling without letting in too much sunlight. This

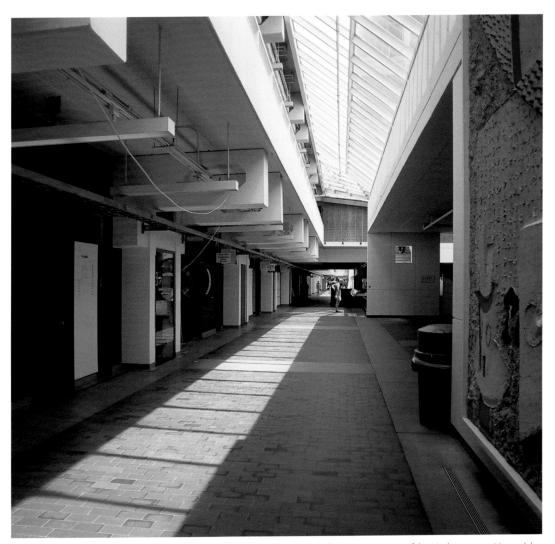

Science Center

(among other things) helped to fine-tune the designs of these architects whose buildings often had flat roofs with decorative tilework, were painted white, or featured large porches over the accessways, thus permitting large doors and windows without overheating the interior. All of these resourses Sert and the GATCPAC group learned directly from regional architecture which already formed part of a tradition and was not expensive or difficult to carry out in its environment.

One element that interested Sert was the organization of the house around a central patio, a layout found in the architecture of Ibiza and that of many other regions of the Mediterranean. He used this scheme in his house in Long Island, NY, as well as in the Maeght Foundation and many other buildings. This plan makes different solutions possible and provides illumination not only from outside of the building but also from its central atrium. Another signature element used by the architect is the use of skylights which diffuse homogenous light throughout the interior without generating too much heat. These lights also confer a highly distinctive shape to the exterior silhouette.

The even light on Miró's detailed paintings is what allows the flat colors and the perfect definition of the contours of the

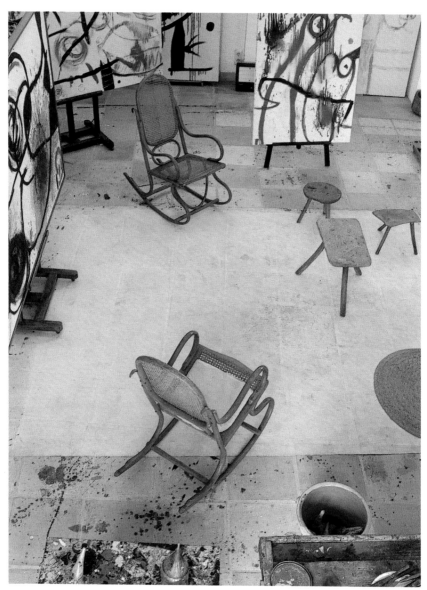

Miró's studio in Palma de Mallorca

objects: it is a light that bathes the landscape without creating many contrasts, as in the painting *Montroig*. The sun in *The Farm* is very high, the midday sun, a sun that brings about an almost unreal clarity and whose light can be captured by objects from all angles, without shadows.

Miró detested painting under artificial lighting, and the large studio in Palma de Mallorca was a space where he could work with a uniform natural lighting without the least difficulty and without being limited in terms of space. All of this allowed him to approach large formats. In thhis the studio he worked for hours but also simply spent time observing the development of his paintings.

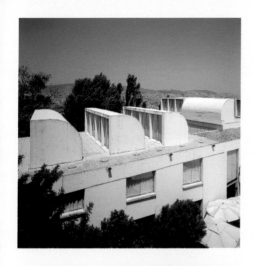

The skylights mark a very particular profile in Sert's works, as is certainly the case with the Miró Foundation. This kind of lighting allows the walls to be used for functions other than housing windows, which is the case in the Law Library at Boston University, where the vertical planes are filled with books.

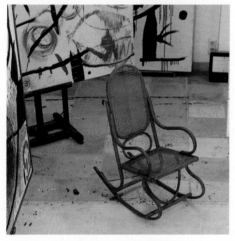

The construction of Miró's studio in Palma de Mallorca by Josep Lluís Sert was one of the great dreams of the Barcelona-based painter. He found in the studio a large work space that was very comfortable. It became the place he most loved, not only a place to paint, but a sanctuary from which to observe the ongoing progress of his pieces in different lighting conditions throughout the day.

Figure and Bird is one of the pieces done in the large studio in Palma. Miró worked right on top of a panel from a large crate. The rapid, unbroken flourish of the stroke is influenced by Japanese calligraphy as well as by his admiration for the North American school, where the continuous brushstrokes on the canvas were first used with such absence of inhibition. In this detail, the eye of the figures dating from this phase of Miró's work can be appreciated—as can the nails in the original crating material, which Miró wanted to preserve.

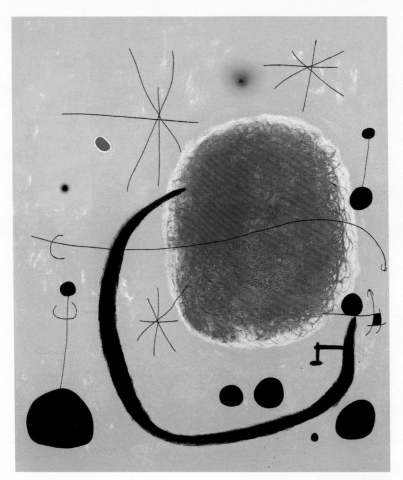

The Gold of the Azure
1967. Acrylic on canvas (80³/₄ x 68¹/₃ inches)

BASIC COLORS

Regulating space,
understanding life

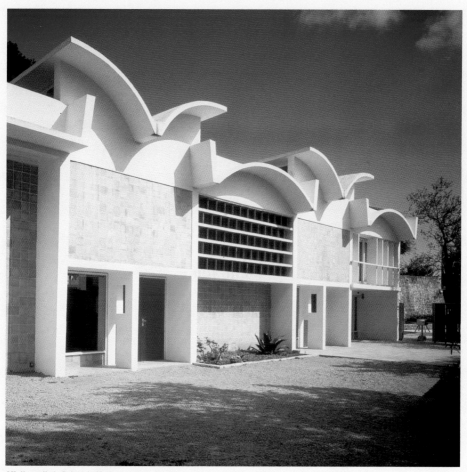
Miró's studio in Palma de Mallorca

One characteristic of Miró's work is his use of basic colors in a constant process of synthesis and pictorial purity. Sert, interested in creating a simple, pure architecture free of any superfluous element, investigated the use of primary colors as an element to arrange a building's façade visually. He worked with color as an element that is subtle, but never banal.

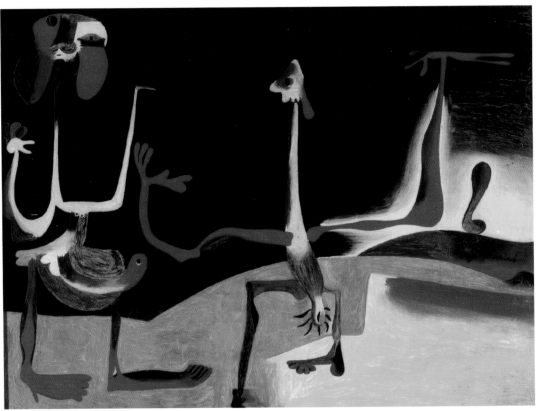

Man and Woman in Front of a Pile of Excrement
1935. Oil on copper (9¹/₅ x 12³/₅ inches)

Miró paintings show a mastery of the use of pigments. He has a fine sensitivity for color, above all in his mature period, when he used a minimal range almost reduced to primary colors, with a self-control that allowed him to create compositions of great force from a few colored forms. Color theory had been fundamental to Miró from the time of his youth. Francesc Galí (1880-1965), the Barcelonan painter and teacher, was impressed when he evaluated the young Miró's entrance test for his school. Galí had prepared a series of objects lacking precisely in chromatic richness, from which the student had to devise a still life. The result in Miró's case was a work based specifically on these colors, which surprised Galí so much that he accepted the young painter unconditionally, in spite of the difficulties Miró had shown with draftsmanship. Galí's academy provided the foundation of Miró's training, though it seemed that the

ability to work with color was already very strongly developed in him. Miró continued to develop this pictorial quality throughout his career.

Sert, like other rationalist architects, introduced color into many of his works but left his concrete surfaces bare out of respect for the material. He occasionally used color to set up a rhythm in the façade or to bring out the accessway, as is the case in the Miró studio, a building which he planned through constant collaboration with the painter and which was born of this mutual understanding between the two. The building is whitewashed, like typical Balearic Island buildings, but the doors are painted in pure colors that establish minimal contrast—as do the roofs—with the surroundings. This subtle work with color can also be found in the Maeght Foundation, where throughout the building are diverse chromatic touches—a yellow wall, a blue wall—that contrast

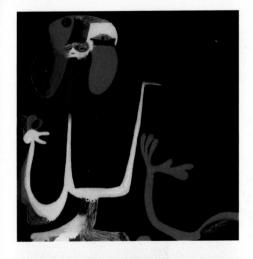

In *Man and Woman in Front a Pile of Excrement* (1935), two human figures stand out on a black background. The palette used in this painting is very bright and underscores the violence of the scene, in spite of the preference for basic colors: while it does not eschew the use of different tones of the same color, here and in other paintings of the same phase one sees the continuation of the trend begun in the years when *The Farm* was painted. The use of a limited chromatic range is intentional and serves to achieve a degree of greater synthesis and purity. This path was followed in the *Constellations* (1940) and subsequent works, although Miró will also used the color orange in a rather exquisite way in *Drop of Water on Pink Snow* (1968), a work with an otherwise minimalist palette.

In the phase that includes the wild figures, Miró turned to a range of very aggressive colors he had not previously employed. In spite of using a repertoire of basic colors, without much mixing, he sought contrasts and delineated the deformity of bodies whose parts have different colors. Ears, for example, or eyes stand out because of their strangeness. His interest in representing space progressively diminished and was eventually indicated only by a vague horizon line brusquely separating the two monochromatic zones. This creates a very hard frame for the two figures, with a very different solution than what was the case in the subsequent paintings, as in *Woman in the Night* (1940), where the horizon serves to delineate a minimum distance between the terrestrial and the celestial.

Compared to Miró's work, Sert's use of color in the Maeght Foundation is more subtle and less expressive. For Sert, color is not essential to his profession but rather something to introduce into architecture as an important element. Sert shunned the gratuitous, and thus his use of color always was used with a reason. Color in this building is dedicated to the arts, with an identity of its own, applied directly onto the unpolished cement. This emphasizes the impression of the wooden molds, normally very visible in the works of the architect. Sert established a highly varied rhythm of building materials: cement, brick, stone, raw tiles. With these elements he established a rich palette that is not monotonous, and he used it throughout the edifice, always respecting the idea of creating a space that accompanies the building, without any architectural elements that come between the piece and the viewer. Color is one way of enriching this neutral but never boring frame that accompanies the visitor around the architect's buildings.

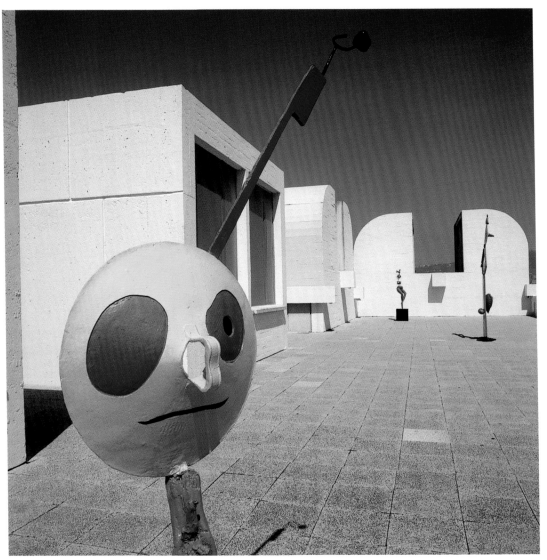

Woman and Bird
1967. Painted bronze
($79\frac{1}{2}$ x $40\frac{1}{5}$ x $35\frac{4}{5}$ inches)

with the stone, brick, and concrete planes. Apart from these edifices, which are related to the art world, Sert also used color—always in its pure state—in other structures, such as the George Sherman Union at Boston University. There, red, via a few minimal elements (the interior handrails and the small panels in the façade),

provides the leitmotif.

Clearly, the use of color is very different between these two: the chromatic quality we see in Miró has a capacity for emotion and fascination not possessed by Sert. That which drives Miró's work is mere detail to Sert, a play with subtleties. However, it is important to see how there

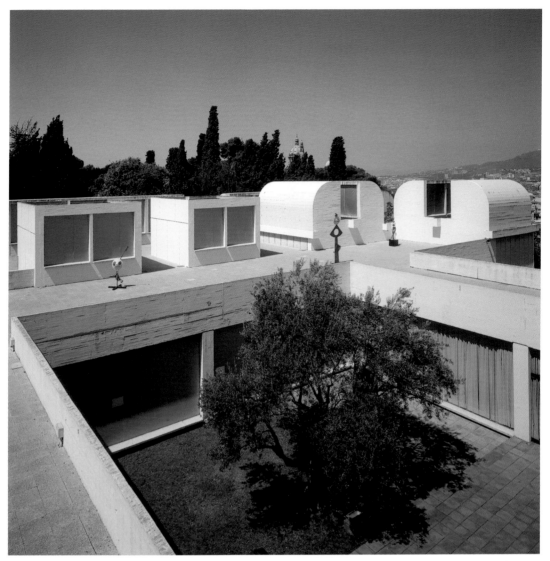

Joan Miró Foundation's terrace

is a generational exchange among the rationalist architects and the painters of their time, specifically between Sert and Miró. Both men were interested in pure forms, in a language free from historical constraints and universally accessible, in addition to showing a fondness and respect for the traditional or provincial.

It comes, then, as little surprise, that Sert turned to primary colors in consonance with the ideas of simplicity and purity of his time. This is even more understandable if we consider that he worked at Miró's side.

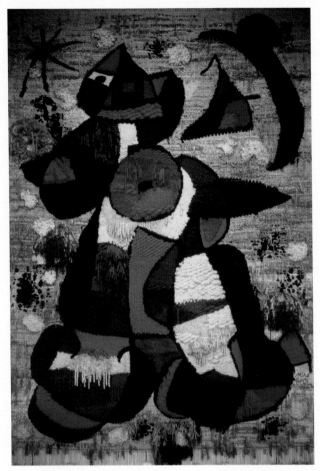

The Foundation Tapestry
1979. Wool (295¹/₄ x 196⁴/₅ inches)

THE INFLUENCE OF FOLK ART

Learning from artisans

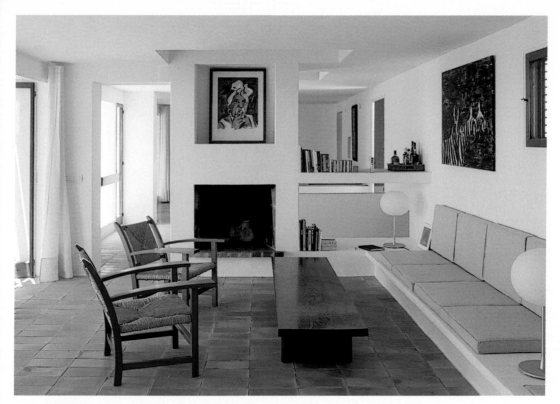

House in Punta Martinet

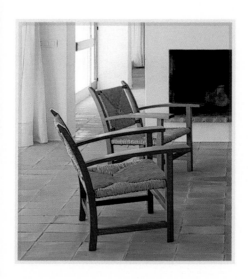

Miró always considered himself to be more of an artisan in the tradition of his grandparents—blacksmiths on the paternal, cabinet-makers on the maternal side—and he admired all popular traditions. Sert, raised in a different social stratum, found in traditional Mediterranean architecture the bases for a rational architecture adapted to this climate while using new materials—iron and concrete—without losing touch with conventional ones such as ceramics and brick.

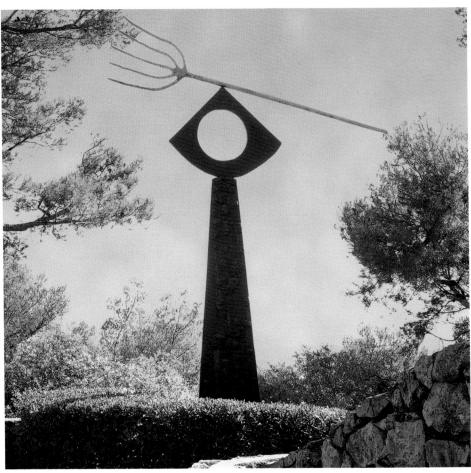

Fork
1963. Iron and bronze
16 feet 7¹/₂ inches x
14 feet 11 inches x
3¹/₂ inches)

Miró always considered traditional arts and crafts an element that linked the farmer directly to his land: for this painter, it was the sign of an absolutely authentic art, much more profound, much richer than the forms of any painter or any historical school. He also considered it an example of the basic skills every person of country origins possessed to successfully deal with their environment, using only materials in the immediate surroundings. His admiration for these simple objects, which had a definite and easily managed use, was shared by Sert who, like the painter, kept folk objects he admired and could use in his house, although not to the extent a collector would.

Sert studied the houses of Ibiza and found in them the principles for a southern rationalist architecture. He always tried to work with the same ideas of simplicity and coherence he had seen in the typical structures found on the Catalan coasts. When he worked on other continents, he never ceased to interest himself in the typical local building styles, mixing them with what he had learned in his beloved Mediterranean. In Latin America, he learned to design a type of house covered with branches. This was a widespread tradition in many parts of the continent, and it served his needs to create a hygienic, comfortable, and very inexpensive house.

Miró picked up a number of objects associated with local culture from different parts of the world during the trips he

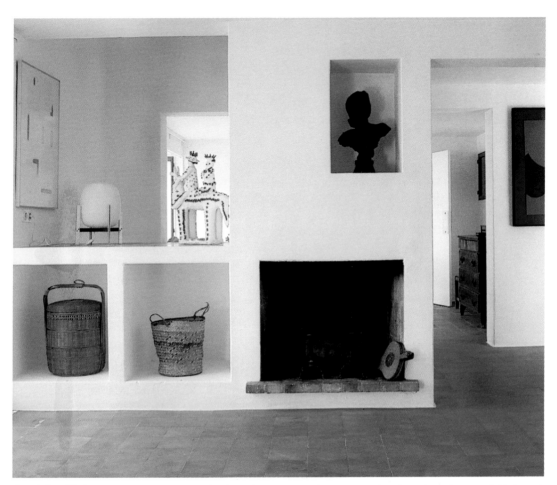

House in Punta Martinet

made, but what seems to have most attracted his interest were the objects from Mallorca and Camp de Tarragona, which were closer to his home. One of the first exhibitions at the Miró Foundation was on *bombes de paper*, paper balloons that were very popular during Miró's childhood and that had always fascinated him. This show was an homage to a popular tradition that had already been lost. Another tradition that he liked involved the flower carpets that were made in Montroig and he tried always to be in the town at Easter time in order to see them.

The passion for local culture is not infrequently mixed with the taste for constant innovation: Miró introduced provincial elements in many of his sculptures—a

three-legged stool or a pitchfork—and assembled them together. He also did no small number of ceramic mosaics and took a great interest in tapestries, on which he worked with Josep Royo (1945-), using new techniques both in the weaving and in the creation of materials to create pieces that were much simpler than the tapestries created by predecessors in the history of art such as Goya, Titian, and Velázquez.

When he worked on Punta Martinet or on the Miró studio, Sert tried to respect as much as possible the shape of the irrigation tanks for the old planted fields. To do this, he reconstructed some of the walls using the same technique. The modernist architect always attempted to inject new

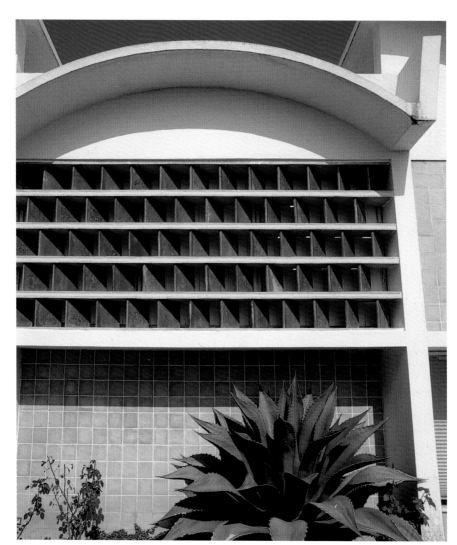

Miró's studio in Palma de Mallorca

life into architectural forms. However, he did not hesitate to take advantage of traditional elements, as in these two houses, or in his Locust Valley house, built from an old farmhouse with a good part of its original form left intact and the interior readapted.

Both of these artists were fascinated by traditions they considered intelligent and by the cultures that constructed their own tools from what they found around them, living in harmony with nature, without requiring too many things. Both were aware not only of the beauty and perfection of this world but also that it was being eclipsed by the inexorable process of industrialization and inordinate growth of urbanization throughout the Iberian levant and the Balearic Islands. Their protests, however, accomplished little.

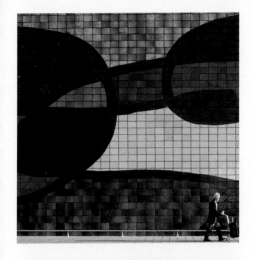

Miró began to work in ceramics alongside Josep Llorens Artigas (1892-1980), with whom he had remained good friends from the time he was at Francesc Galí's school. The first ceramic mural he made was done for Harvard University to replace a painting Miró himself had done some years earlier and had incurred damage. In these murals, like the one in the Barcelona Airport (left), the artist plays with the texture of the baked ceramics and the different tones acquired by the pigments, thus exploring the craft.

In Miró's studio, Sert used large baked ceramic tiles for the floors (the standard practice in many houses in Mallorca). He also took advantage of the qualities of this same material to cover the exterior walls, thus distinguishing clearly between these exterior walls and the major concrete structural walls.

It is not unusual to find ceramic pieces in Sert's work, above all in his buildings in Catalonia, because this material is commonly used in this part of the Mediterranean. The walls of the Miró studio in Palma, for example, are covered with ceramic elements, as are the roofs of the anti-tuberculosis hospital in Barcelona (1935-38) and the Punta Martinet houses. The exterior lighting for the swimming pool in Punta Martinet also has ceramic elements, rescued from basins used to collect water from a mill. (Such basins are common in the island's irrigation ditches and water mills.) Sert liked them so much that he found a craftsperson that made them and ordered some with special openings to let the light pass through.

JOAN MIRÓ

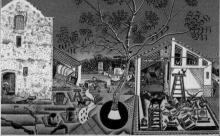

JOAN MIRÓ 1893-1983

Joan Miró is one of the greatest painters of the twentieth century. Although he was part of André Breton's surrealist group, his work should not be read exclusively through the prism of this avant-garde movement. Miró established a universal language in his drawings, one capable of bringing about communication with any other human being, despite cultural, geographic, or temporal differences. He did not create an artistic movement but did exert an influence on artists of subsequent generations: both in North America (Rothko, Pollock) and in different European movements like Parisian Art Brut (Dubuffet) or the Barcelonan Dau al Set (Tàpies). These groups are in Miró's debt in regard to pictorial language, not only his refined shapes but also his technique (the use of color, the search for materiality, and the constant innovation).

Miró was born in Barcelona in 1893, and he always felt close to the "City of the Counts" and to Catalonia as a whole. His father, a watchmaker and silversmith, came from a family of blacksmiths from the Camp de Tarragona region. His mother's family worked as cabinetmakers and came from Majorca. The painter credited the artisanal traditions of both sides of his family as influential to his work, as were his ancestral lands. Camp de Tarragona was a magical place for the painter; he met his wife, Pilar Juncosa (1904-1995), in Majorca and lived there for a long time.

In 1907, Miró registered at the School of Commerce in Barcelona, following his father's wishes. However, the young Miró attended another school, La Llotja (School of Industrial and Fine Arts). Later, his father made him work as an accounts clerk at the drugstore of Dalmau y Oliveres, where he spent two hard years alienated from painting. As a result, he fell ill in 1912 of a nervous depression complicated by typhoid fever which made his family move him to the country, to the farm which his father had just purchased in Montroig, in Camp de Tarragona. Here, Miró discovered the almost sacred relationship between the country people and the land. He also decided here to dedicate himself completely to painting, a resolution which his family accepted. The same year, he registered at Francesc Galí's art school, where the teacher used progressive methods. Miró, who had problems with draftsmanship, learned to make drawings by touch. Blindfolded, he had to run his hands over an object and later draw it from the memory of this tactile sensation alone. He spoke of this experience many years later, after branching out into ceramics, and recalled the importance of discovering the sense of touch as part of the painting. In addition to this, in the open environment of Galí's school, Miró discovered the work of Van Gogh, Matisse, and Picasso, as well as avant-garde journals that were published in Paris and in Barcelona.

His painting progressively acquired more personality, distancing itself from the Fauvism of his first pieces. In 1920, he made his first visit to Paris (welcomed by such other Catalan artists as Josep

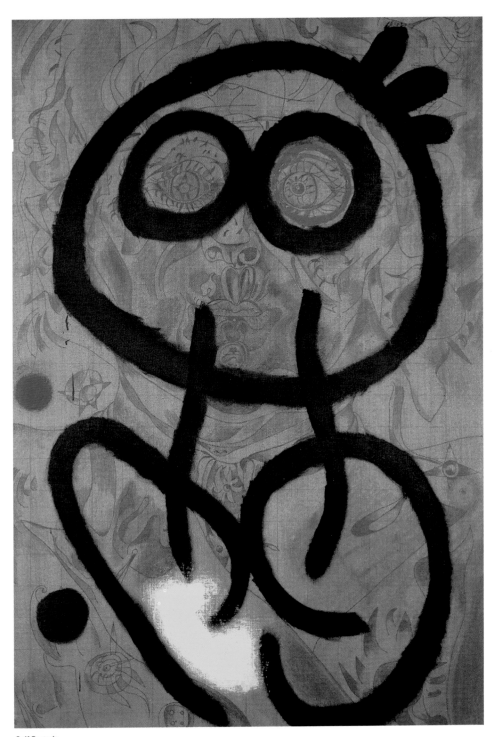

Self Portrait
1937/38-1960. Pencil and oil on canvas (57³/₅ x 38¹/₅ inches)

Pla (1897-1981), Josep Llorens Artigas, Joan Salvat-Papasseit (1894-1924), and Joaquín Torrres-García (1874-1949), among others). There, although he didn't paint, Miró diligently visited the Louvre and the collections in the Luxembourg. He also met Picasso, thus beginning a friendship and great mutual lasting admiration. The sojourns in the city of light became more frequent and prolonged until, finally, he and his wife moved there in 1930. The 1920s were Miró's apprenticeship period in the Parisian avant-garde scene: he became acquainted with the work of Paul Klee (1879-1940) and made the personal acquaintance of the dealer Daniel-Henry Kahnweiler (1884-1979). He also met many young writers and poets with whom he was fond of getting together: Raymond Queneau (1903-1976), Antonin Artaud (1895-1948), Robert Desnos (1900-1945). He met the Breton group which, in 1924, published the first Surrealist manifesto. However, along with the bustling activity of his Paris life, Miró frequently returned to Montroig. This contact with his native land and the Tarragona landscape was indispensable to him. He needed it not only to be able to paint but to be able to live; it served as a counterpoint to his life in cosmopolitan Paris.

Starting in 1924, now part of the surrealist group, Miró began to receive recognition, and his first one-man show the following year was successful. However, in spite of belonging to the Breton group, Miró followed his own personal path. Because of this he never ceased to seek refinement, the synthesis of his discoveries and solutions. His pieces are the result of long meditation and prior study. His sketchbook never left his side and is filled with rapid drawings and notes. Even the smallest scrap of paper sufficed for him to begin to dash off drawings with a frenzied intensity when an idea came.

The 1940s were marked by catastrophic wars in Spain and the rest of Europe. In the face of these wars, Miró took refuge in his painting without ever abandoning interest in his surrounding environment. Retrospective shows in New York in 1941 and in Paris in 1946 conferred on Miró international prestige. He was at the high point of his art. In 1944, he began to work with the ceramist, Llorens Artigas, and made his first sculptures. Miró's pictorial language, by now fully formed, still continued to evolve, as did his interest in new materials and new techniques.

In 1956, at a time when Miró's fame was growing internationally, one of his dreams came true with the construction of a large studio by his friend Josep Lluís Sert. Another dream was fulfilled with the Miró Foundation in Barcelona, created as an active cultural center for the beloved city of his birth.

Throughout his life, Miró continued to investigate ideas that had always interested him such as vacancy and space, concepts which appear in his famous triptychs in the early 1970s and in his large sculptures. He continued his constant capacity for innovation until his death in 1983. During the last years of his life, Miró grew aware that his work had extended the scope of painting, bringing new life to artisanal traditions through the discourse of so-called high culture.

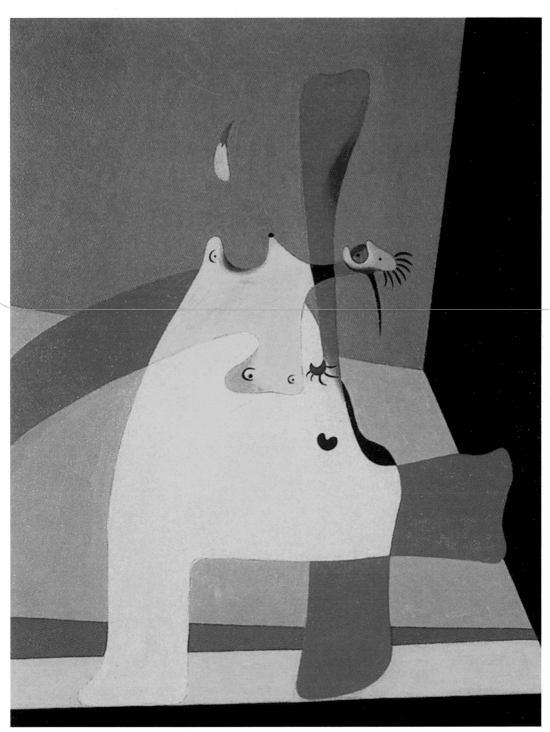

Flame in Space and Nude Woman
1932. Oil on wood (16^1/$_5$ x 12^3/$_5$ inches)

THE FARM

1921-1922. Oil on canvas (28$^4/_5$ x 25$^3/_4$ inches)

The Camp de Tarragona region, especially Montroig, remained a vital place for Miró. There, he discovered an almost supernatural relationship between mankind and the land: the painter was fascinated by the harmony of the village and its surroundings, where the seasons marked the passage of time and the landscape everywhere bore a human imprint: tilled fields, houses, mills, irrigation equipment, wells...

Between 1918 and 1922, Miró spent long periods in Montroig painting the Tarragona landscape that entranced him. *The Farm*, begun there and finished in Paris, was the culmination of this entire process. This piece shows the relationship between mankind and the land: people need the earth as much as trees do. Faced with these convictions which were revelations for him, Miró found himself fascinated by the men and women adapting and cultivating the land. Miró was not interested in the obvious but grasped the power behind simple everyday actions in country life. The complexity of this apparent simplicity fascinated him, like a child observing its surroundings for the first time with clear, discovering eyes. Therefore everything seems organized with a clarity that has been called idealized or supernatural, despite his lack of connection at the time to André Breton's group. A flat register without perspective on a horizontal plain is the basis of Catalan Romanesque painting, a style Miró made a point of studying in the Museum of Catalan Art (Museu d'Art de Catalunya). He admired the simplicity of line in these paintings and the strength of the figures.

Here, we see how Miró began to feel confident and bring to maturity his own visual vocabulary, putting in elements that continued to appear throughout his work, evolving slowly with the passage of the years. The sun, looming in the center of a monochromatic sky, is an early incarnation of that future vocabulary, and the fusion of the figures with the background marks a path which he continued to investigate, thereby arriving in later years at a tense balance between background and figures.

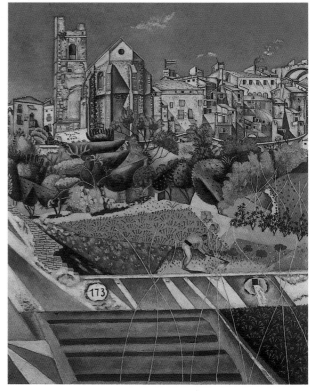

Montroig: The Church and the Village
1919. Oil on canvas (28$^3/_4$ x 24 inches)

THE BOTTLE OF WINE

1924. Oil on canvas (28$^4/_5$ x 25$^3/_4$ inches)

This piece, done in Paris and dedicated to the painter's parents, belongs to a fundamental period when Miró was training himself to paint in his developing vocabulary: after *The Farm*, Miró considered his period based on an expressive realist manner finished and he was ready for a change. Moreover, Dadaism had rocked the foundations of the Parisian intellectuals, Breton was beginning to prepare the Surrealist manifesto, and all of Miró's friends were involved in a similar search for reform.

The theme of this piece is the same as in his previous period: the elements appearing here—a bottle of wine, a worm, and an insect—refer to the world of the farm, the world of Miró's native land, but they are organized here in a peculiar way. The change in scale (the worm is as large as the bottle of wine) reflects the importance he assigns each element. A total freedom with the canvas begins here: the painter finds himself in front of a space free of any conventions and paints only through the filter of his feelings and his interests. In *Painting*, for example, we find him seeking a simple composition without the background serving as a reference point defining the space. This simplicity is also present in the background of *The Bottle of Wine* and in other works from this phase such as *Tilled Field* (1923). References to Montroig are ever-present, such as the label on the bottle, *Vi* (Catalan for wine), regardless of the fact that in the sketches it was in French (the language Miró tended to use in many Parisian pieces), and the closeness to the earth, like the volcano in the bottle, a motif he used as a symbol of the power of the earth.

Painting
1925. Oil on canvas (28$^3/_4$ x 39$^2/_5$ inches)

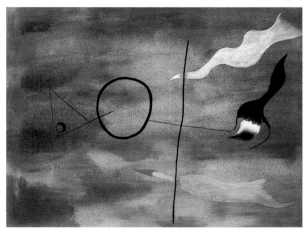

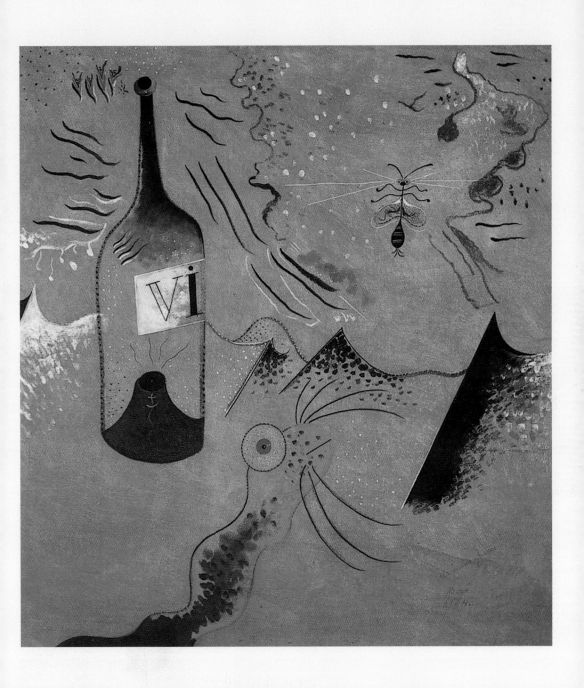

PAINTING

1933. Oil on canvas (51¹/₃ x 64 inches)

In 1933, Miró put his painting ability and the degree of simplification and purity he could attain to the test. He created 18 collages as drafts on which 18 paintings were based.

The methods he used for this piece show both his constant technical innovation and his interest in highly controlled creative processes. His point of departure was a series of simple, monochromatic collages consisting of advertisements cut out of newspapers glued onto pieces of paper. The layout establishes a series of relationships among the objects which Miró studied prior to painting the final version onto the canvas. This transference of collage to painting involves a total transformation. It follows a logic that makes this piece the most abstract and purely formal of Miró's artwork and also perhaps the most fully avant-garde. The collage elements, recognizable in the first step (pipes, propellers, knives), no longer appear as such on the canvas, where they make up part of an organic entity in a play on decontextualization and reassignment of signifiers rather close to Marcel Duchamp's "readymades."

The concept for the project was to create a distance between the subject of the painting and the final piece, which obligates the artist to set very strict rules and give more freedom to the painting than to his imagination. His goal was to abstract each one of these forms, to seek their most pictorial reality and represent the object in its maximum simplicity, although this means that in the painting all references to the initial objects are lost.

These works were done in Barcelona but were shown for the first time, and with great success, at the gallery of Georges Bernheim in Paris in October of 1933.

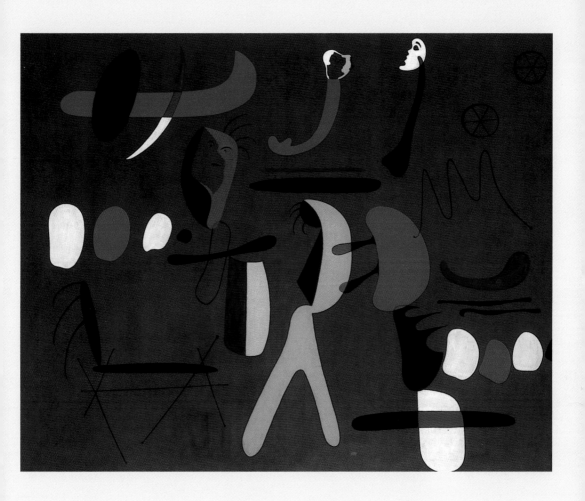

Preparatory collage for Painting
1933. (18$\frac{1}{2}$ x 24$\frac{4}{5}$ inches)

Preparatory collage for Painting
1933. (18$\frac{3}{4}$ x 24$\frac{3}{4}$ inches)

Preparatory collage for Painting
1933. (18$\frac{1}{2}$ x 24$\frac{4}{5}$ inches)

Preparatory collage for Painting
1933. (18$\frac{1}{2}$ x 24$\frac{4}{5}$ inches)

Nude
1937. Lead pencil on paper (13¹/₅ x 10¹/₅ inches)
Nude
1937. Lead pencil on paper (14¹/₂ x 8¹/₄ inches)

NUDE WOMAN ASCENDING A STAIRCASE

1937. Lead pencil on paper (30³/₄ x 19³/₄ inches)

In 1935, Miró began work on what he termed "Wild Paintings." Without any biographical changes to explain it, his work took a surprising turn, and he began to create a series of figures that were extremely terrifying and deformed. According to some critics, this expressionist turn, removed in certain ways from the Parisian avant-gardes, was a premonition of the coming disaster. It was more of a crisis of his belief in the world, which he intuited to be falling apart, rather than a personal crisis. The latter came later on his return to Paris in 1936. Hence, in the city that meant so much to him, he felt doubly exiled: first because of the brutality of the Spanish Civil War, and equally because of the passivity he saw in his second home, the French capital.

After the "Wild Paintings," when his fears had become a reality, Miró found himself unable to paint. He then forced himself to paint when he returned to the Grand Chaumière, the studio where students went to practice figure drawing with live models. Perhaps what he sought there, besides a workspace (since he lived with his family in a hotel at the time) was the sordid atmosphere of the large studio and its harsh treatment of both art students and art models.

The drawings show a severe, confident line that had previously been absent in Miró's work. The figures, twisted and deformed, express above all the contained energy and the liberation of his return to painting, his believing in something in spite of all. These pieces are a great exercise in capturing reality because with a simple stroke of the pencil Miró captured the gesture, the vibrant flesh, and the posture of the whole body.

A figure worked on beyond simple notebook form, *Nude Woman Ascending a Staircase* is a drawing reminiscent of the wild figures of a few years earlier, as if now he had recovered his capacity to paint. The subject, a nude woman shouting and bearing her teeth, somewhat resembles Marcel Duchamp's *Nude Descending a Staircase*. Although Miró greatly admired Duchamp, this painting is a clearly intended perversion. There are many similarities—the title, the stair, the lines indicating motion, the decomposition—but are also apparent differences. Miró's piece could be a self-criticism as well as a criticism of the 1920s, a time when it had been unnecessary to commit oneself to anything because at that time there had seemed no possibility of any threat.

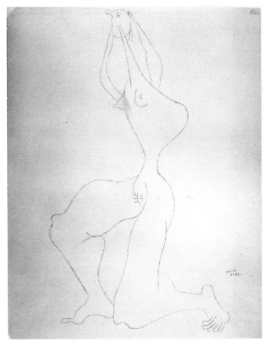

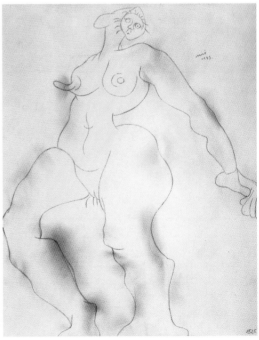

MORNING STAR
(FROM CONSTELLATIONS)

1940. Tempera, gouache, egg, oil paint, and pastel on paper.
(15 x 18¹/₁₀ inches)

The Constellations series consists of 23 small pieces which Miró did over a period of two years. The series was started in Vargenville, a small town on the Normandy coast where the artist lived in 1939, while coming to terms with the impossibility of returning to Spain and the hardships of living in Paris. The barren landscape of Normandy, a place so different from his beloved Camp de Tarragona, and the dark nights of the little town, with the stars burning brightly in the firmament, made a great impression on him. The discovery of this natural landscape after five years of Paris life and no contact with the country, and also the aggressive state of mankind, explain to some degree the impulse behind the Constellations, a series considered by many critics as one of the highest points of Miró's career and in twentieth-century painting.

After having lived though the freedom of the Europe in the 1930s, especially in the Spanish Republic, it was hardly surprising that Miró avoided painting. To Miró, the natural order of the universe and human nature contrasted sharply with the oppressive brutality of the times.

Miró was absorbed with the series to the point of abandon. Having decided to return to Spain because of the advancing Nazis, he didn't evacuate Vargenville until the last train for Paris before the invasion of the German troops. The return was not easy: Joan Prats, a gallery owner and friend of Miró, was awaiting him in Girona, Spain. Prats persuaded the painter to not return to Barcelona, as the Catalan capital was the scene of ongoing arrests and firing squad executions, making it unsafe. The Miró family settled in Palma de Mallorca where, in spite of the turmoil, the painter continued his work.

In the small pieces in this series, Miró gave shape to an earthly world with very few elements. The stars, codified into black points, two superimposed crosses, two opposing angles, and irregular five- or four-pointed shapes, make up new constellations of Miró's archetypal beings. The background and figures merge into a single plane via highly thought-out compositions organized on the surface of the small canvas. The arrangement is expansive, with an attempt to avoid hierarchy such as centrality and directional axes, and to occupy the whole expanse of canvas or paper. We are left with the perception that this particular world extends beyond the limits of the canvas.

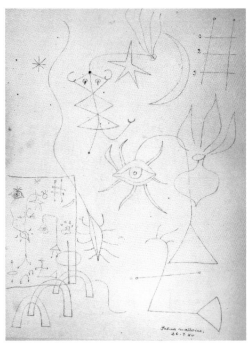

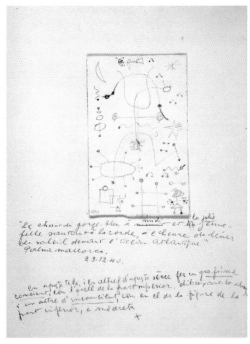

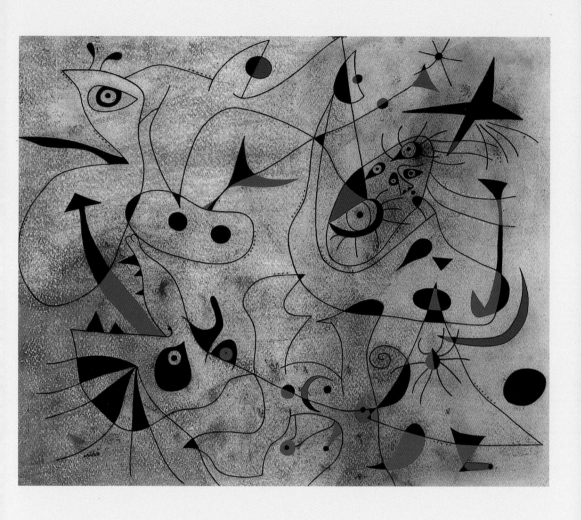

The Wings of a Sea Swallow Beat with Joy before the Charm of a Dancer Whose Skin Is Made Iridescent by the Caresses of the Moon
1940. Lead pencil on paper (12²/₅ x 9²/₅ inches)

The Song of the Blue Bird at Midday and the Pretty Girl Jumping Rope at Daybreak before the Atlantic Ocean
1940. Lead pencil on paper (5⁹/₁₀ x 3³/₄ inches)

WOMAN DREAMING OF ESCAPE

1945. Oil on canvas (51$^1/_5$ x 64 inches)

Between 1942 and 1943, Miró primarily worked on paper, creating work on which many later pieces were based. This is the case with *Woman Dreaming of Escape*. The woman, eyes, stars, sexual organs, birds, and escape ladder (the group of stars in the shape of a modified sharp musical symbol on the upper left side of the canvas) are the minimal elements which the painter used. These are stylized silhouettes, even the modified sharp sign, never repeated in any two paintings, though always recognizable.

In *Woman and Bird by Night*, the figure of the woman does no more than affirm its own existence. The eyes and the sexual organ are elements which, as in his previous cosmologies, participate with the stars. From these, the artist affirms his figures within the cosmos, within their star-populated environment. However, the white space between the figures totally isolates them from each other: communication becomes an impossibility. Miró works against traditional ideas of composition in Western art. Instead of integrating the characters into the narrative of the pictorial plane, he divests himself of the convention and lets the figures float, separated, in the white. Only certain chromatic elements create order in the work by their repetition. These elements are the dots, the sinuous forms, and the colored notes. These elements give the piece its dynamic quality.

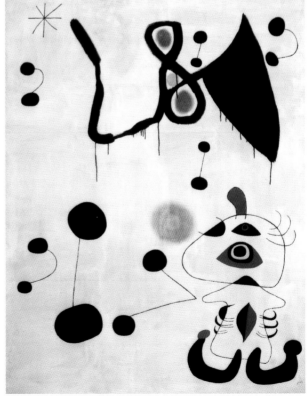

Woman and Bird in the Night
1945. Oil on canvas (57$^3/_5$ x 45 inches)

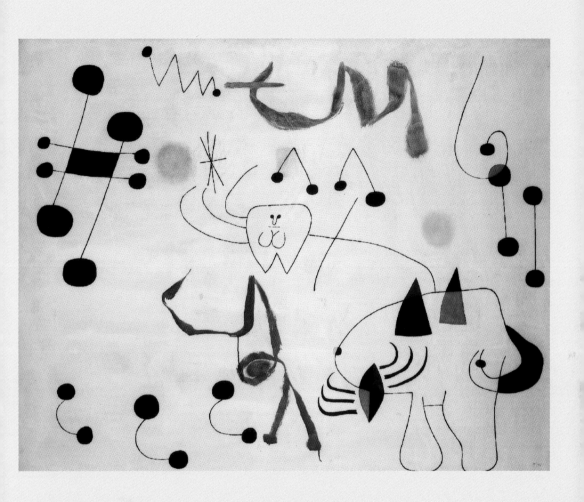

The Hope of the Man Condemned to Death I, II, III

1974. Acrylic on canvas (105¹/₅ x 138²/₅ / 105¹/₅ x 138²/₅ / 105¹/₁₀ x 137⁹/₁₀ inches)

This work belongs to a series of triptychs done between 1964 and 1974. They are the same format as the triptych titled *Blue I, II, III* (approximately106¹/₃ x 139³/₄ inches). The entire series was conceived as a reflection on such elements in painting as the void—in front of and inside of the pictorial space—the painted spot and line, the chromatic surface, and their spatial implications. In all of these paintings, Miró's language reaches a point of total purity, dominating these large formats with a minimum number of elements. Preparatory sketches for the triptych exist, such as *The Hope of the Man Condemned to Death* of the previous year. These demonstrate the long period of meditation that gave rise to these canvases which appear to be so gestural.

This triptych owes its title to one of the last death sentences of the Francoist regime; Miró painted it, after much meditation, on 9 February 1974, the same day when, for political reasons, the Anarchist militant Salvador Puig Antich was executed. According to statements Miró made, he was unaware of the coincidence in the dates until several days later, when he understood that in a terrible way his painting had recorded the violent end to a life: the interrupted line, the suspension points—like rifle shots, although Puig Antich died under the garrote—and the tension in the painting's every part. Miró's work was the response to the brutal murder of the young man, and he took it to his large retrospective exhibition in the Gran Palais de Paris that same year. The hope to which the title alludes is not only that of a single person but that of an entire country, a country which had to suffer the final abuses of power at the hand of a dictator and his accomplices, when they yearned for freedom which at last seemed within reach.

Blue I, II, III
1961. Oil on canvas (106¹/₃ x 139³/₄ inches)

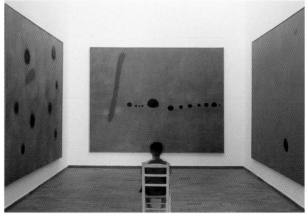

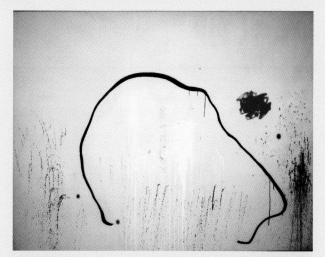

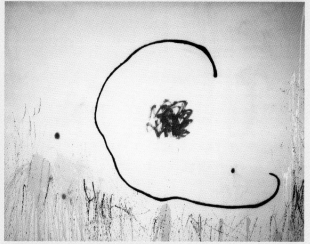

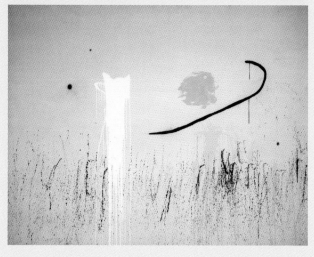

HEAD

1940-74. Acrylic on canvas, (25³/₅ x 19³/₅ inches)

Between 1973 and 1974 Miró undertook the series
generically known as *Heads*. Black, which always had
a particular importance in Miró's creations (primarily to
outline the figures, as lines, and as small patches), in this
series takes on the leading role of the whole canvas,
almost wholly covering it. One of the few elements that
distinguishes between these heads is the eyes. From the
time of his first portraits, Miró assigned great
importance to eyes—we recall *Portrait of a Young
Girl*—and this organ is a characteristic that normally
stands out in his archetypal characters, the lunar or
celestial birds, for example.

This series of work coincided with Miró's preparation
for his 1974 retrospective in the Grand Palais in Paris.
Dissatisfied with the very idea of the retrospective, a
show that for all practical purposes was giving more
importance to his past work than his recent pieces, he
decided to take some 200 works to the French capital,
a good half of them done in the previous year. He also
decided to repaint many of his pieces from the
Constellations period, to the total dismay of many art
critics, who considered these to be his greatest
achievement. Confident, wide black lines cover nearly
the entire canvas, leaving bare only the odd element of
primitive painting. *Head* is one of these repainted
pieces, and what was previously a star is now this
figure's penetrating eye.

Miró, always restless, did not hesitate to carry out this
"destruction," or transformation, of his works. The artist
was more than once capable of taking a language that
had already become fixed and suddenly altering it,
though in a way consistent with his opus and the
evolution of his particular world.

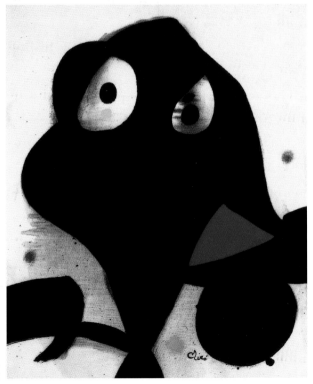

Head I.
1974. Acrylic on canvas (29 x 23³/₅ inches)

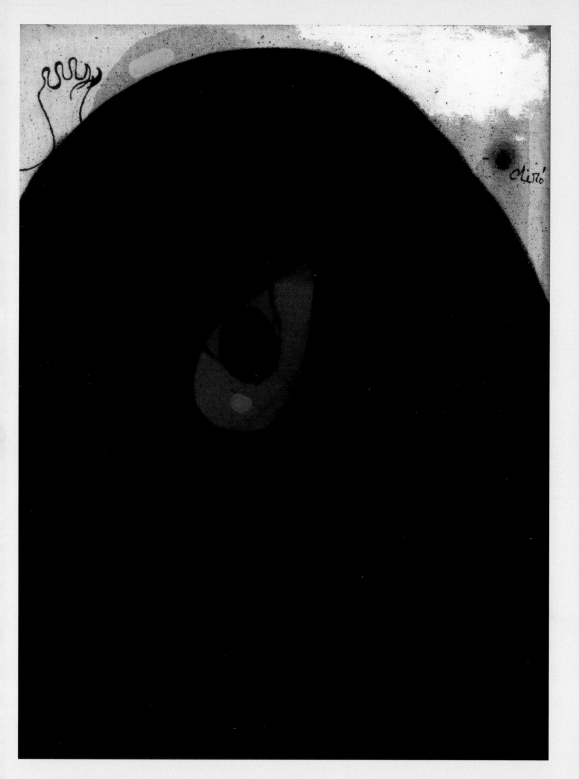

LIST OF IMAGES

JOAN MIRÓ

JOSEP LLUÍS SERT